MW00604287

ASHEVILLE
GHOSTS AND LEGENDS

Best Wishes

Ken W Traylor

Dalas House

ASHEVILLE
GHOSTS AND LEGENDS

KEN TRAYLOR
DELAS M. HOUSE JR.

Haunted America

Published by Haunted America
An Imprint of The History Press
Charleston, SC 29403
www.historypress.net

Copyright © 2006 by Ken Traylor and Delas M. House Jr.
All rights reserved

Cover Image: An ornate cross marks a grave at Riverside Cemetery.

First published 2006
Second printing 2008
Manufactured in the United States

ISBN 978.1.59629.156.0

Library of Congress Cataloging-in-Publication Data
Traylor, Ken, 1947-
Asheville ghost and legends / Ken Traylor and Delas M. House, Jr.
p. cm.
ISBN 1-59629-156-7 (alk. paper)
1. Ghosts--North Carolina--Asheville. 2. Haunted places--North
Carolina--Asheville. I. House, Delas M. II. Title.
BF1472.U6T73 2006
133.109756'88--dc22
2006018771

Notice: The information in this book is true and complete to the best of our knowledge. It is offered without guarantee on the part of the author or The History Press. The author and The History Press disclaim all liability in connection with the use of this book.

All rights reserved. No part of this book may be reproduced or transmitted in any form whatsoever without prior written permission from the publisher except in the case of brief quotations embodied in critical articles and reviews.

This book is dedicated to our two great kids
David Jesse &
Dakota Allen
who have brought new meaning
and purpose to our lives.

To our two terrific "nephews"
Gage & Mathew

To my best friends, David and Ann Lynch,
who know what being a friend is all about.
They are an inspiration and a
"Rock of Gibraltar" for me.

Also, dedicated to my mom, Carol House,
and in memory of my dad, Delas M. House Sr.
Thanks for always being there when I most needed you.
I love you very much.

And finally, in memory of my mom, Elvirez (Breezy) Traylor,
whose wisdom and guidance are the guiding lights in my life.

Contents

Acknowledgements

We would like to acknowledge the following people for their help in researching this book:

Robert Chrisman
Dustin Caudill
Christy Riopelle
Lindsay Gulya
Beth Strickland
Davis Sanders
Frank Salvo
Ralph Coffey
The staff of the historical section of the main Asheville Library

Introduction

Believer? Non-believer? Fence sitter of the paranormal world? Aww, well, come along on this journey and decide for yourself what you should be. Keep an open mind as we venture from one legend to the next, ever watchful for the shadowed details that will convince you one way or the other.

Ever felt a cold chill when it was warm or hot outside? Ever turned around quickly to see who was behind you and find nothing there? Ever thought you heard a voice speaking to you but there was no one around to say anything? We all have throughout our lives. Some of us disregard it, some of us wonder, and like myself, some of us know what it is. Now you know exactly where I stand on this subject, as if any of you reading this should have had a doubt. Even though I know what the truth is, I shall let the legends do the convincing.

Asheville being a rather unique community, tucked away between the two oldest mountains ranges on earth—the Great Smokies and the Blue Ridge—has a very interesting, if not strange, history. The Appalachian Mountains, being over 350 million years old, provides ripe and fertile ground for ghost legends to take root. First known human inhabitants of this area where the eastern band of Cherokee

Indians, who obviously found the area abundant with plenty of food and the winters rather mild compared to farther north. Being a highly spiritual group, they have throughout their history been strong believers in the spirit world, and many of the legends in the mountains surrounding Asheville pertain to their past ancestors.

Pioneers from the Virginia area first settled Asheville starting around the 1750s. They were the hardiest of stock and needed to be, as conditions were very crude and harsh. As a result, many deaths occurred unnaturally.

Asheville was incorporated into a city on November 11, 1795. Formerly know as Morristown, it was renamed for a former Governor of North Carolina, Samuel Ashe. In 1806 the city fathers discovered an interesting fact: the town square—the site of several public buildings including the county's courthouse, located approximately where Pack Square is today—was actually in the hands of private landowners. Realizing this situation had to be rectified, they set out to purchase the land, paying a whopping $105.01.

Many distinguished people started to migrate to these beautiful mountains beginning around 1870. With the completion of the railroad in 1880, the boom was on.

The event that really put Asheville on the map was George Vanderbilt's decision to build his fabulous Biltmore Estate here. It remains the country's largest home with some 256 rooms. Mr. Vanderbilt attracted many of his friends to the area, most of whom shared Vanderbilt's interests in writing, architecture, forestry, art and travel. Many of these friends, as well as many of the architects and highly skilled workers brought over from Europe to built Biltmore, ended up staying in Asheville the rest of their lives.

Even though Asheville has a rather long history, today it is a vibrant city, filled with cultural diversity unique to the mountains. Home to some seventy-three thousand residents within the city

limits and over two hundred fifty thousand in the county, Asheville is the thirteenth largest enclave for writers, artists and craftspeople in the country. The city is also blessed with the riches of old architecture, due in large part to George Vanderbilt. Asheville is the second largest art deco architectural community in the country next to Miami, Florida. Many of the legends in the Asheville area are an integral part of these buildings.

So now you have a thumbnail sketch of this hidden treasure tucked away in these most glorious of mountains.

What makes a person remain in the spirit realm for all eternity, or at least until they are able to finally move on? When someone dies from unnatural circumstances, such as an accident, violence or an unexpected medical condition, they will often remain in the spirit realm. Why is this? Common belief among investigators of the paranormal field is that one of two things occurs: the deceased don't realize they have died or they feel they have an uncompleted task in this realm that needs to be taken care of before they can pass over to the other side.

Alas, one question leads to another: what is the other side? The other side is the place we go to when we have stopped living. If you have ever read any books on the subject of the near-death experience, almost without fail, the author will tell of their journey of leaving their physical body and then heading towards a white light. Often they report that it is the most comfortable feeling they have ever had, and they see waiting for them at the light a number of loved ones and or friends who have gone before them, beckoning to them to come through the light. Most report that they truly did not want to return to this realm we exist in but, for whatever reason, are sent back to their physical bodies.

Now, that you have a sense of what the spirit world is about, let's explore some of the ghosts and legends of Asheville.

The Ghost of City Hall

In 1929 Asheville was like the rest of the country, feeling the results of a decade-long economic boom. It had constructed many architecturally splendid buildings in the downtown area, many of which remain to this day. The Montford area was full of beautiful homes and mansions of the rich: some famous, some infamous.

Life was good until the stock market crash of 1929. When the bubble burst in October of that year, Asheville, like most of the nation, deflated rapidly. The city that was hit the hardest due to the Great Depression wasn't New York, Chicago or Los Angeles but Asheville, North Carolina. Why? The city is the only known city to have completely repaid all of its pre-Depression era debt. Asheville burned the last of its paid off debt bonds in 1976.

When the stock market crashed on Black Tuesday, October 29, 1929, the city's financial manager had the vast majority of the city's money invested in the stock market: not exactly the safest place to put your money during that era. The city's fortunes fell from an estimated $187,000,000 to a little over $88,000,000. Of course, the city went into instant debt and eventually reached bankruptcy. Blame spread around city hall like wildfire through a dry forest. Working feverishly around the clock, the financial manager applied every trace of his expertise to finding a way out of this dilemma. Becoming extremely

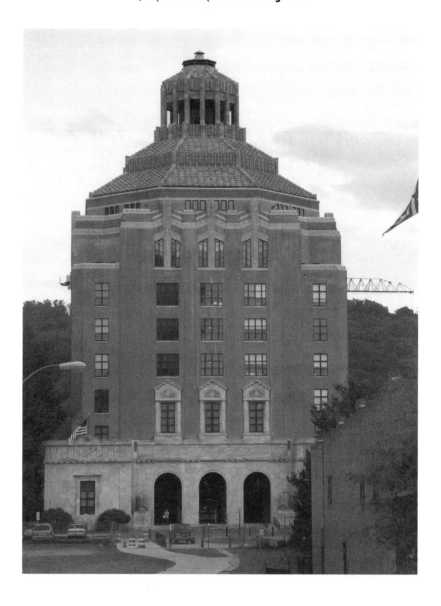

depressed, he came to work one day shortly after the crash dressed in his usual attire of a three-piece suit and tie. He was met with what had become an all-too-familiar cold reception by all of his co-workers. Proceeding up the elevator to the top floor of the magnificent art deco building that is city hall, he finished his journey by climbing the stairs

to the roof area and gazing out across the majestic mountains that surround the city for one last time. He plunged to the street below, landing in front of the building entrance, instantly killing himself.

He apparently feels the need to complete his task of running the city's finances, even though facing his peers was too painful, for his spirit has been reported at city hall ever since that fateful day.

Often a gentleman in a three-piece suit appears throughout the building, primarily in the snack shop area located on the main floor. He apparently has taken up residence in the snack shop area and loves to appear to his contemporaries and visitors alike, standing in line and acting as if he is going to order something. It is regularly reported that when someone approaches the snack shop to order there is a gentleman in a rather old looking style of suit in front of them. Patiently waiting for the man to order, the customer is scared to wit's end as the gentleman simply disappears from view.

About twelve years ago a gentleman named Rick McDaniel, now a freelance writer for the local daily newspaper in Asheville as well as other newspapers, purchased that snack shop. He reported that on his third or fourth day of ownership he went in early to prepare the kitchen for the day. Bending over to get items from a carton on the floor, Rick said he noticed someone standing beside him. Looking over he noticed the man had on a rather old-fashioned suit. As he rose to inform the gentleman that he was not prepared to serve anyone yet, the man just disappeared. Rick reported he wanted to find the very first person he could and hand over the keys to the shop, wishing them good luck. Unable to find anyone at that early hour, he simply brushed it aside as a bad dream.

Rick, over the course of the next four or five weeks, made a number of changes to the business, which would be normal for a new owner. Rick reported that after every major change some very strange events would take place. Following every change, he would arrive to work early the next morning and kitchen utensils would be scattered around

on the floor! On two occasions knives were thrown from a wall rack to the other side of the kitchen, fortunately not aimed at him. After the last event, Rick said, he connected the dots and figured out that the gentleman did not like changes to his favorite haunt. Rick never made any other major changes and the events stopped. Rick kept the business for about another year and then sold it, always feeling uneasy about the place and its resident. He reported that for several years afterward he continued to have dreams and nightmares about the gentleman in the three-piece suit.

Apparently, the old financial manager has other daily routines that he performs often. It is frequently reported that items on different desks throughout the building will be rearranged by no apparent soul. Also, being a typically conservative financial manager, he likes to save as much of the city's money as he can by turning off air conditioners and lights on a regular basis.

One of the city employees relates a story that confused her for a long time, but she now knows where it is coming from.

Shortly after starting work in the building, she came to work one morning to find her cubicle had been somewhat rearranged. Her chair was on the wrong side of the desk, the wastebasket was over in one corner and her telephone had been placed under the desk. She was a little upset at what she was sure was the cleaning crew for not returning those items to their proper places. Shrugging the incident off, she replaced the wayward items and went about her job.

After several weeks with no new occurrences, she had forgotten all about the incident. However, one morning she arrived at work only to find her office rearranged again. Being upset, she reported it to her supervisor, who assured her that she would mention it to the cleaning company. That afternoon the supervisor reported back that she had spoken with the company and they told her that they would make sure the night shift supervisor was made aware of the situation, promising that it would not occur again.

Nothing happened for another three or four weeks until the woman came to work once again to find her office in disarray. Now furious over the apparent incompetence of the cleaning staff, she immediately got her supervisor and escorted her back to the cubicle. The supervisor said she would put an end to this nonsense and went straight away to call the cleaning company.

The owner of the company came over within twenty minutes to see the rearrangement for himself. He assured everyone there that he would personally take charge of the situation and oversee what was happening for the next several weeks.

Every night the owner, as he had promised, checked on the work his employees were doing. Everything was going well, and after three weeks of being there every night, he was satisfied that his staff was performing their duties properly.

Much to his surprise, the very next morning the owner received an angry phone call from the supervisor at city hall, complaining about the same situation. He was speechless, to say the least, since he had personally overseen the operation. He knew that he was the last person to see all the offices, having made one final round after his staff had gone home. All had been good.

Not being able to explain the event, he offered not to charge the city for his services the previous night.

The rearrangement continued several more times with no logical explanation.

Finally, in frustration, the owner did not try to retain his contract when it came due and to this day still cannot explain what was going on.

So, the next time you are in downtown Asheville and want to experience a truly beautiful and architecturally unique building, visit the City Hall of Asheville. If you should get hungry or thirsty while there, just remember there is a terrific little snack shop on the first floor. You just might get more than you ordered!

The Legend of Richmond Hill

Resting high atop a hill overlooking the French Broad River, just outside of downtown Asheville, sits a most magnificent Queen Anne style home built originally by Richmond Pearson in 1889. The house is quite substantial, very spacious and inviting. The interior and exterior both hearken back to a bygone era of fine and luxurious living. The walls are covered in Asheville's native woods such as oak, walnut and cherry. In the drawing room, the walls are lined in the original pink silk damask that was the fashion of Pearson's day.

The library contains a wealth of early original documents and books. Letters and other official papers from five presidents adorn the room; one from President Andrew Johnson is dated June 1865. A letter from within the family dated November 16, 1807, addresses the possibility of war with Great Britain once again.

The house boasts many valuable antiques from all over the world. The collection consists of many exquisite pieces of furniture, the finest of rugs, china and rare glass art. The collection also contains silverware, one piece being made for the family by renowned silversmith Samuel Casey around 1750, and a gold and diamond snuff box from the Louis XVI period.

The home was the focal point of both social and political activity in Asheville during Richmond's life. Richmond was a politician of some note in North Carolina, both as a state legislator and a U.S. congressman. Under President Theodore Roosevelt, Pearson served as Minister to Persia and Envoy

Extraordinary and Minister Plenipotentiary to Greece and Montenegro. Retiring from the diplomatic service in 1909, he returned to Asheville to concentrate on his law practice. In 1923 Pearson died at Richmond Hill, the one place on earth he truly loved.

Other deaths that occurred in the home were those of his son, Richmond Pearson Jr., who died of scarlet fever in 1900; another son, Thomas Pearson, who succumbed to a heart ailment in 1963; and the only daughter, Marjorie Pearson, suffered a long illness and died on May 25, 1972. The house was then willed to a cousin by the name of General Hayne Davis Boyden.

Boyden sold Richmond Hill to the North Carolina Baptist Home, Incorporated, in 1974, with the stipulation that the home was to be preserved for a period of ten years. During this time the Preservation Society of Asheville and Buncombe County made many efforts to maintain the house. In 1981 the Preservation Society purchased seven and a half acres of land adjoining the original home site in anticipation of a future purchase and possible move. The Preservation Society conducted a three-year - long fundraising effort to gather the one hundred thousand dollars necessary to relocate the house six hundred feet.

In 1987 a Greensboro, North Carolina, firm purchased Richmond Hill and proceeded to completely restore the home to its original glory. In 1989 Richmond Hill opened as a beautiful bed and breakfast inn and conference facility.

Under normal circumstances, this is where the story would end for an interesting historic home, but alas, this is no ordinary house!

The home has many guests other than the ones visiting the bed and breakfast. Richmond Pearson dearly loved Richmond Hill, as did his entire family. Many believe that the home is still occupied by Richmond, his son Richmond Jr., daughter Marjorie and youngest son Thomas.

Guests at the inn commonly report strange events. It seems that Richmond, in his mind at least, is still the master of the mansion. He is seen walking both the interior and exterior of the home as if surveying all that he owns. Guests report seeing a distinguished-looking gentleman, dressed in an old-fashioned suit with a high-collared white shirt, slowly walking the hallways, especially late into the evening and at night.

One such report had Richmond walking the halls late one evening as a guest existed from his room. Much to the terror of the guest, Richmond simply passed directly through him, leaving the visitor with cold chills throughout his body.

On several occasions, guests who have come to tour the home have been greeted with more than just a "regular" tour. Marjorie and Thomas love to walk alongside of stray guests and show them the "real" Richmond Hill. It has been documented such guests do not finish the regular tour and are seen scurrying off to their cars.

The Legend of Richmond Hill

The best-known legend of Richmond Hill is that of Zelda. "Zelda" was Zelda Fitzgerald, wife of F. Scott Fitzgerald, author of *The Great Gatsby* and many other writings. F. Scott Fitzgerald and Zelda visited Asheville on several occasions during their marriage.

In her younger years, Zelda was a vibrant and beautiful young woman. She enjoyed life to the fullest and loved to explore and travel with F. Scott. They roamed the world together and enjoyed the somewhat fleeting fame and fortune of her husband. F. Scott was a well-known drinker of no small magnitude, and Zelda enjoyed the fast paced lifestyle right along with him. She was also a painter, dancer and writer of a number of books and short stories on her own.

In her later years, Zelda developed mental illness and would be sequestered on several occasions in Highland Hospital in the Montford District of Asheville. F. Scott would stay for a while to be near her but would often leave on extended trips. Twice Zelda was released and traveled to meet up with F. Scott, who by this time was always broke and drunk, writing magazine stories and whatever he could to survive.

Zelda's mental illness progressed to the point where F. Scott could no longer handle her. She returned to Highland Hospital one last time in 1948. Shortly after her return to the hospital it caught fire, and she was unfortunately burned to death.

It is said by many that Zelda remains in the spirit realm, hopelessly awaiting the return of her beloved F. Scott.

Why, then, does she appear frequently at the Richmond Hill Inn? It is believed that—not having a place to remain upon her sudden death as the hospital had burned to the ground—for years she roamed Asheville and its surroundings looking for F. Scott, believing that their love for each other would reunite them.

In her travels to find him, Zelda happened upon Richmond Hill and has remained there because she found a room named F. Scott

Fitzgerald. She has been reported by guests and staff to be seen late at night in a ballerina outfit, dingy and torn from much use, dancing at the top of the staircase landing to the second floor. She no longer appears young and attractive, but rather old and somewhat stocky, looking nothing like the typical image of a ballerina. She has a crazed, faraway look upon her face and in her eyes. Her eyes tell of a long struggle for sanity and her inability to cope with life.

If confronted by talking to her, she will begin to howl like an animal and scream. If you dare ask her who she is, she reportedly yells back, "I am Zany Zelda!"

Although not seen as frequently as in the past, Zelda stills makes a mad hatter appearance on occasion. Sometimes seen with Zelda is a man, looking for all the world like F. Scott Fitzgerald. It is believed that F. Scott does return from time to time to be with his beloved Zelda, but eventually wanderlust strikes him once again, and he ventures off to some unknown place until his next visit with her.

One particular guest reported that while visiting Asheville one summer with her two grandchildren, wanting to teach them about some of the great writers that had either been born here or resided here, a very strange occurrence happened.

While sitting around the inn's dining room table one evening, the conversation took a strange twist when the ten-year-old granddaughter started describing an event she had witnessed the night before. She stated that a woman dressed in a ballerina costume and a man dressed in a tuxedo had been in her room the prior evening. She said, although she could hear no music, they started to dance a waltz. Then suddenly they vanished. The little girl said she had not been afraid, as they appeared to be very nice and smiled at her.

The grandmother and the little girl's older brother smiled and reassured her that it was simply a dream. The little girl became a bit upset, insisting that it was real. The grandmother silently raised one hand and the little girl stopped talking. It was as if this were a long-

rehearsed ritual that the grandmother used when she preferred to no longer discuss a subject.

The rest of the evening was spent exchanging pleasantries concerning their day and what they could anticipate for the events of tomorrow. Shortly after dinner the trio retired to their respective rooms for the evening. Feeling exhausted from all of their activities of the day, the little girl soon was fast asleep.

About two o'clock in the morning, the granddaughter suddenly bolt upright in her bed, having been aroused from her slumber by some unknown force. Appearing before her, once again, were the ballerina and the tuxedoed man, dancing.

The little girl began to cry; she knew for a fact that this time she was not dreaming this event. She arose from her bed and quietly slipped out the door of her room, completely ignored by the dancing pair.

The granddaughter dashed down the hallway and into her brother's room, awakening him with a harsh shove, yelling that he had to come and see for himself the people in her room. Being a little irritable at having a very pleasant dream disturbed, he told her to go back to sleep in her room, for she was only having a nightmare. She started to cry, and not wanting to be responsible for upsetting his sister, the boy squirmed his way out of his warm environment and trudged down the hallway to her room.

Upon entering, he was greeted with exactly the same image that his sister had described the evening before at dinner: the strange-looking dancing couple.

Fearing that some harm could come from the pair, the brother grabbed his little sister's hand and dashed back to his room. He made her promise not to speak of this to anyone until he could figure out what the truth was.

He did not sleep a wink for the remainder of the night, and his grandmother noticed it immediately that morning at

breakfast. In her particular grandmotherly way, she inquired as to the meaning of his disheveled appearance and red eyes. Hesitating for fear of the scolding that surely was about to follow, his voice quavering, he stated to explain the events of the past evening. Not wanting to see the stare that his grandmother was guaranteed to be giving him, for she could stop a fast moving train with her look, he continued his story while examining his shoes, wondering why he could not control his feet from moving back and forth so rapidly.

When he finished his tale, he was met with a thundering, deafening silence. For what seemed to be an eternity but was actually only a few moments, his grandmother shattered the air with her soft and gentle voice.

She proclaimed his story to be one that she found most interesting. After several moments of contemplation, she began to tell her grandchildren how she had witnessed the exact same event just two evenings before.

Being a rather dignified lady, she was not particularly inclined to believe in the supernatural but had to admit that her perception of what she had witnessed had changed upon hearing the tale from her grandson.

So when traveling through this part of the world, if you want to experience a beautiful bed and breakfast, then by all means stay at Richmond Hill.

Oh, by the way, ask for the F. Scott Fitzgerald room. Hopefully you will have your own "Zany Zelda" and F. Scott Fitzgerald experience to pass along to your grandchildren, if you dare.

The Legend of the Basilica of St. Lawrence

There stands in Asheville a most beautiful place of worship: the Basilica of St. Lawrence, a Roman Catholic church in Spanish Renaissance style. The primary architect and builder of the structure was Rafael Guastavino. In the early 1890s, George Vanderbilt brought the Spanish Guastavino to Asheville from New York to help design the Biltmore Estate. Having fallen in love with the beauty of the area, the architect decided to make Asheville home.

Now, if you have not heard of Rafael Guastavino before, then perhaps you will recognize some of his other famous designs: Grant's Tomb, the Great Hall at Ellis Island, Grand Central Station, Carnegie Hall and the chapel at West Point.

In 1905 Guastavino decided to design and built his final masterpiece, the Basilica of St. Lawrence. Its massive stone foundation and solid brick superstructure lend testimony to Guastavino's desire to build an edifice that would stand for many generations. You will not find any wood beams or steel within the structure: all floors, walls, ceilings and pillars are made from tile and masonry. The amazing roof is covered in copper.

Upon entering the church, one is struck by the opulence of the interior, especially the elliptically shaped ceiling, which measures

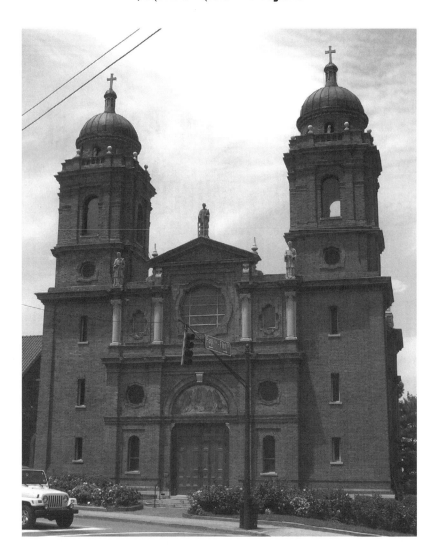

fifty-eight-by-eighty-two feet. The material used to cover the ceiling is a brick tile laid in a herringbone pattern. Lying on his back, Rafael painstakingly placed each tile, using an ancient method that he is credited with reviving. The ceiling is reputed to be the largest free-standing elliptical dome in North America.

The church was completed in 1909; however, as Guastavino died in 1908, he did not see its completion. Guastavino's son completed

the church per his father's wishes. The architect had two other wishes that he conveyed to his son from his deathbed. The first was that he be buried in a tomb within the walls of St. Lawrence, and the second that it be built large enough for the remains of his wife and daughter to be buried alongside him upon their passing.

His wishes were followed, and upon completion he was interred in the tomb. Some years later the city of Asheville passed an ordinance stating that no one could be buried upon private or public property, only in regulated cemeteries. Guastavino's wife and daughter lived the balance of their lives in Asheville, but due to the ordinance, they were buried in Riverside Cemetery about a half mile from the church.

Many believe to this day that the spirits of both Guastavino's wife and daughter have moved from the cemetery to the church to be with their dearly beloved husband and father. There are numerous reports from staff, parishioners and visitors alike as to feeling of cold patches within the structure for no obvious reason, lights turning off and on and doors opening and shutting with no one in sight.

About twenty-two years ago, a priest at St. Lawrence was sitting in his room watching TV at the rectory that resides next to the church, when suddenly he collapsed and died from a massive coronary.

He dearly loved the church and its parishioners and obviously has decided to remain at St. Lawrence, for his presence is often detected. He was fond of wearing a particular brand of cologne and whiffs of it can be smelled within the church and particularly in his old room at the rectory.

A parishioner, who had been a member of St. Lawrence for many years, knew the priest very well and was a great admirer. Saddened deeply by the passing of his friend, he often felt that he could sense the priest's presence and smell a faint hint of his cologne. He imagined this to be simply a longing for his friend and spiritual leader.

One day during the week, the man stopped by the church in the middle of the afternoon, feeling the need for some private time in

the church to pray and meditate. He reported that he was praying in his pew when suddenly a cold chill came upon the back of his head. Disturbing him from his meditation, he turned to see where the draft had come from. Nothing appeared out of the ordinary, and he went back to his private thoughts.

Suddenly it felt as if someone had sat upon his shoulders, the weight being almost more than he could bear, causing him to lean forward and nearly lose his balance in his seat. At the same moment, the entire area around him became quite cold. At this point he knew that this was not just some mere coincidence and truly a divine visitation, but from whom? And why?

Fearful that something terrible might be about to happen to him, he dared not move. As he furiously prayed for mercy, he heard a voice that was all too familiar to him, calling out his name. Without reservation he knew it was his old friend, the priest.

Answering back, the man asked what was it that he could do for his old friend. The priest reassured his friend that he meant him no harm. The priest realized that he had been missed and only wanted his parishioner to know that he was well and had been watching over him.

Just as suddenly as the priest had appeared, he disappeared.

The parishioner said that from that moment forward he felt a new inner peace and a renewed zest for life. He no longer feared death but knew when his time came that he would be reunited with his friends and loved ones.

In a phenomenon common in older churches, many parishioners who were very devoted to their church will remain in and around the structure they so loved. This is particularly true with St. Lawrence. There have been many incidents where guests on a local ghost tour, after stopping to hear the history and legends of the church, have recorded on their cameras literally hundreds of spirit orbs and apparitions around the building. Some guests have had the unusual

experience of detecting many orbs right in front of them when they use a digital camera and can view the results instantly.

If you are privileged enough to ever visit Asheville, stop by the Basilica of St. Lawrence, located next to the Civic Center downtown, and worship or just visit. Do not be surprised to hear a sermon from an unseen priest or perhaps to be nudged on your pew by an invisible parishioner. You may even be inclined to make an extra large donation.

The Spirits of Riverside Cemetery

Just a stone's throw away from the Basilica of St. Lawrence sits the picturesque Riverside cemetery. Perched upon eighty-seven acres of rolling hills and flower gardens, it overlooks the French Broad River. Dating back to 1885, it is one of the oldest cemeteries within the confines of the Asheville city limits. The Asheville Cemetery Company established the land as a municipal graveyard to answer the growing need for burial grounds. Asheville Cemetery Company was successful in getting the city to pass an ordinance around 1910 that prohibited the burial of anyone on private or public property within the city limits. The city of Asheville adopted the cemetery in 1952 and operates it to this day. It is a very active cemetery with over thirteen thousand gravesites, some nine thousand monuments and twelve family mausoleums. Many of the current graves were relocated from previous sites and reinterred there.

The cemetery is open during the daytime for visitors to visit with some of the interred or simply to stroll among the gravestones and the wide variety of ancient oaks, poplar, dogwood and ginkgo trees.

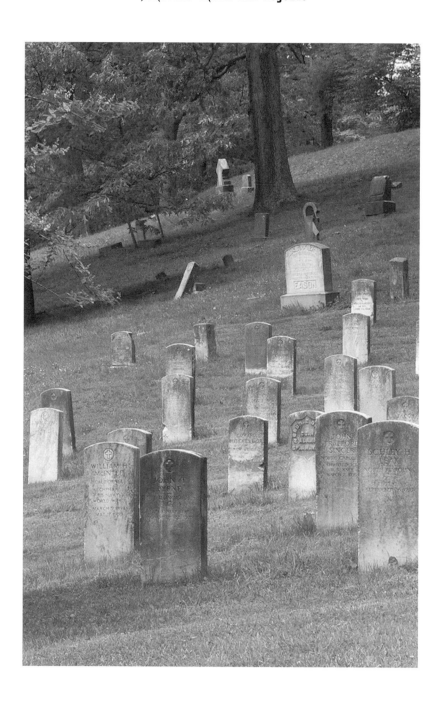

The Spirits of Riverside Cemetery

Although now closed after dusk, you can still approach the cemetery up to the gates and fence. From this vantage point, late at night you can record on pictures as well as tape recorders the entire goings on within the confines of the property.

Riverside is the burial place of a number of famous people, among them noted authors Thomas Wolfe, of *Look Homeward, Angel* fame, and William S. Porter, better known as the famous short story writer O. Henry. Three famous Confederate generals' remains are buried there: James Martin, Robert B. Vance and Thomas Clingman. A number of the city's more prominent citizens are interred at Riverside, including Jeter C. Pritchard, T.S. Morrison, Thomas Patton and Zebulon B. Vance, the Civil War governor of North Carolina and a lifelong politician. As mentioned in the last chapter, Rafael Gusatavino's wife and daughter's earthly remains are in the cemetery. There is also a section for Confederate soldiers from the Civil War as well as eighteen German sailors from World War I. James Posey, a bodyguard to Abraham Lincoln, is also buried there.

For many years the sounds of a military unit marching in unison can be heard around the grounds of the cemetery. Many believe that this is a number of Civil War soldiers interred there led by one or more of Riverside's Confederate generals. On more than one occasion the nearby residents have reported hearing what surely sounds like rifle fire as if the soldiers are practicing their marksmanship.

Imagine happening upon a group of Confederate military men marching, led by a general around a cemetery. Is it a reenactment? A spoof? I think you can guess the correct answer!

Do you hear the muted voices of the soldiers, the rifle shots? Does the mere thought make the hair on the back of your neck rise?

Also buried at Riverside is Thomas Wolfe, the famous author. Wolfe died from a rare disease known as brain tuberculosis at John Hopkins Hospital in Baltimore, Maryland, at the young age of thirty-eight. He has been reported to be seen walking around the

cemetery, in the vicinity of his grave marker, looking as dapper as he did in life. (You will learn more of Mr. Wolfe in the next chapter.)

There is the legend about a group of teenagers who decided it would be "cool" to sneak into the cemetery one dark and stormy night. Little did they realize at the outset of their adventure exactly how "uncool" it would become before the night was over.

Approaching the wrought iron fencing that surrounds the entire property, they checked out the surroundings to make sure no one was watching. One by one the group scaled the fence and dropped unceremoniously on the dew-drenched grass. Already beginning to feel the fear creeping up their spines, they bravely set out to see what they could discover. As the minutes passed and nothing out of the ordinary occurred, their confidence grew by leaps and bounds.

Feeling invincible, the teenagers began to scurry from headstone to headstone, mocking the supposed boogeymen, assured now that such spirits did not exist.

Being a quite hilly terrain, the youths had entered at the top of the elevation and by this time had reached the very lowest point of the property. It is in this area that the aforementioned Civil War section is located.

The boys now began to play as if they were soldiers in the army, marching back and forth. One youth took command of the group and gave out marching orders, all the while marching through the hundreds of tombstones of the real soldiers.

Crack! Crack! Crack! went the sound of someone firing a rifle right behind the last boy in line. All dropped to the ground like sacks of potatoes, screaming in absolute fear.

Not wanting to raise their heads for fear of being shot at once again, the boys lay motionless. Past them came a group of what were obviously soldiers marching to the command of a deep-voiced leader. The boys felt the air turn cold and heard not only the sounds of the general but also the crunch of the wet grass under the

soldiers' feet only a short distance away. To the last one, the boys knew they were all destined for some horrible fate and cried silently to themselves.

Finally, when they could no longer hear the soldiers, one by one the youths dared to crack open their eyes ever so slightly. Surveying the area immediately in front of them, they detected nothing. Bravely, they raised their heads and surveyed the entire area, and to their absolute relief, discovered they were once again alone.

Collectively, they realized they just might be able to escape. Faster than any of them had ever run before, they raced out of the cemetery, scaling the fence in a single bound.

Where had the soldiers come from? What was their mission? Why weren't we shot? Why weren't we at least escorted off to jail or some other God-awful place? Where did they go? These and many other questions arose between the boys after they were safely out of what surely seemed to be the most haunted place on earth.

When visiting Asheville, make it a point to visit Riverside Cemetery, not only during the day to see all the beauty of the area, but also at night when you can experience a whole other reality.

The Ghost of Thomas Wolfe

Thomas Wolfe was one of the world's great writers. Born in 1900 in Asheville, North Carolina, he was raised in his parents' home, known as Old Kentucky Home. His mother, Julia Wolfe, operated the house as a boarding home for all the "summer people" who came to the mountains to beat the sweltering heat of the Lowcountry along the coastal areas of the Carolinas. Originally constructed in 1883, the home was a large Queen Anne style edifice and contained twenty-nine rooms for boarders.

Wolfe wrote unkindly of his childhood home in *Look Homeward, Angel.* His autobiographical novel describes a tormented youth named Eugene Gant growing up in a dingy Dixieland boarding house in the town of Altamont in the state of Catawba.

Thomas did not appreciate his mother's lack of attention and devotion as a wife and mother; instead she spent her time and talent as a rather shrewd real estate businesswoman.

In 1925, while returning home from a voyage to Europe, he met Aline Bernstein, a very successful set and costume designer for the New York theater community. They began a passionate and turbulent love affair, which endured until 1930.

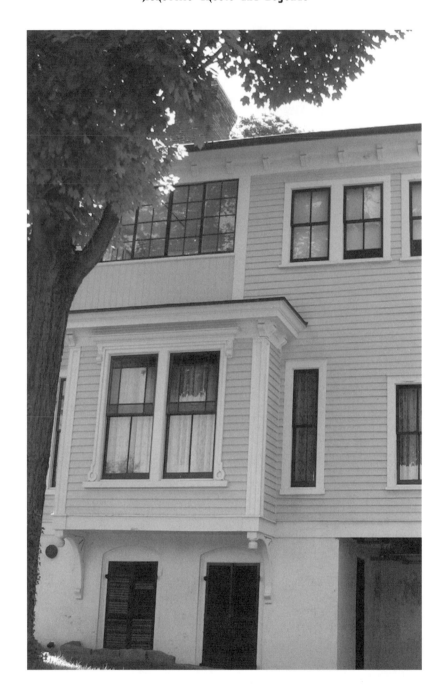

The Ghost of Thomas Wolfe

Wolfe began writing *Look Homeward, Angel* in 1926, and this first novel was finally published in 1929 to much uproar. The novel suffered condemnation from some of the more prominent citizens of Asheville, whom Wolfe had depicted in a not-so-endearing light.

In late 1938, while on a vacation out west, Thomas came down with pneumonia. Doctors were perplexed by the unusual complications that developed. He was admitted to John Hopkins Hospital in Baltimore, Maryland. During a surgery on September 12, it was discovered that the entire right side of his brain was covered with tubercles. Nothing else could be done for Wolfe, and he passed away on September 15, never having regained consciousness.

Wolfe was returned to Asheville and was buried at Riverside Cemetery. A large stone angel was placed upon his gravesite, but vandals kept trying to remove it, causing some damage in the process. A woman in Hendersonville, North Carolina, a community some twenty-five miles south of Asheville, purchased the angel after it was offered for sale by the estate of Thomas Wolfe.

In his twenties, Wolfe would sometimes spend weekends at the Battery Park Hotel in Asheville because they had bathrooms in each room, a luxury not often found in those days. He enjoyed taking a private bath for as long as he desired, instead of being rushed in one of the community bathrooms in his mother's boarding house. To this day it is reported from time to time at the Battery Park Apartments that a bathtub is found to be filling up with water when no one was responsible for turning it on. One can only imagine that Wolfe is still enjoying the luxury he treated himself to many years ago at the hotel.

Wolfe's boyhood home is now a museum. It reopened again to the public in 2004 after a teenage arsonist burned part of the home down in 1998. The state of North Carolina operates the museum and tours are given daily. However, the best tours are not given by tour guides employed by the state but by Thomas Wolfe himself. Even though he intensely disliked the home, he has apparently

returned to a place that he was familiar with in life. It has been frequently reported that he is seen in and around the house, mostly late at night. He has also been seen sitting in one of the rooms at a typewriter, diligently typing away at another novel that only he can conjure up. It is a novel that, unfortunately, we will never be privileged to enjoy.

The legend goes that a caretaker who once worked at the house many years ago was doing a task down on the ground level of the home one evening when suddenly a storage room door burst open. Startled, the man spun around to see who was behind him. There was no one that was obvious to his gaze, so after shutting the door that had most certainly been blown open by a gust of wind, he returned to his job.

About two minutes later the door sprung open again, this time slamming against the wall. The caretaker grabbed the hammer he had been using and cautiously stepped toward the opening, knowing that there was an intruder on the property. The caretaker meant to defend himself.

Shaking from fear of what he was about to face, he decided that charging the opening and yelling at the top of his voice would throw the intruder off balance. He raced into the opening, screaming for all he was worth, only to be met with darkness and some odds and ends stored there. Spinning around and around, so as not to be attacked from behind, he became even more frightened from what was not there than what was.

Who had done this? What was the motive? Where had they gone? These were some of the questions that furiously spun through his head right after the event.

What he came to realize later was that there had been no one there, there was no gust of wind to open the door and he wasn't going crazy; nevertheless, the event had been as real as anything could possibly be. He decided that he would keep this story to

himself until he had some more evidence to confirm his new belief that someone had visited him from the spirit world.

His waiting time was limited to a very short period. About a week later, he reported, he was working on the main floor of the home after closing time, when within a five-minute period about twelve events occurred, in rapid succession.

First, all the lights on the floor began to flicker on and off, followed closely by two windows opening and closing. After a short delay, doors were opened and closed in rapid order. Next, several toilets were flushed, followed by the faucets in those bathrooms being turned on. Finally, right next to where the man was standing, a potted plant moved about six inches.

Then the entire process, in the exact same order, repeated itself.

By this time the man was sitting on the floor, back against the wall, praying for mercy and for this event to cease.

When it finally and mercifully ended, the man looked like he had not slept in many days, his eyes red and puffy. His whole body quivered and sweat profusely.

After composing himself, he calmly got up and walked out of the house, leaving behind all of his tools. He never returned to the home.

When in Asheville, tour through the old Queen Anne style home, but be aware of that cold chill you feel with no obvious source or that touch on the shoulder from no one behind you. When you hear a typewriter, you will know for sure that you are in the presence of one of America's greatest writers. Do say hello!

The Spirits of the 1889 Whitegate Inn and Cottages

I n Asheville, not far from the Wolfe family home, is a most beautiful bed and breakfast. It features spectacular landscaping complete with a Koi pond. A meandering stream winds lazily down the side of the property to another Koi pond.

The Whitegate Inn has a very interesting architectural and ownership history. George W. Pack, of Pack Square fame, built the house in 1889 as a Victorian three-story house with an octagonal tower on the front. The architect believed to have designed the home was James Tennent, an architect of note in Asheville from 1875 to 1900. Tennent was responsible for a number of famous buildings in the downtown area during that period.

The top of the tower was removed in 1907 when the new owner, Frederick Kent, remodeled the house. By the end of the reconstruction, the house bore little resemblance to the original structure.

The home has seen it fair share of owners over its 117-year history. Starting with George Pack, Dr. James Burroughs (1890–1896), Mr.

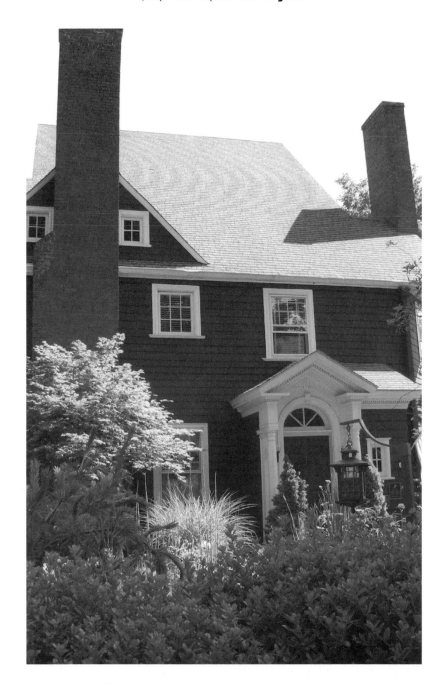

and Mrs. John Carroll (1896–1902), Earl Reynolds (1902–1907), Frederick and Louise Kent (1907–1921), Mabel Grant (1921–1928), Marian Bridgette (1928–1995), Howard Stafford (1995–1998), Michael and Jane Malloy (1998–1999) and the current owners, Frank Salvo and Ralph Coffey.

The house had been a private residence for all the owners until Marian Bridgette's purchase. She purchased the home at the request of two local Asheville physicians to be run as a tuberculosis sanitarium. At the time, Asheville was a respite for people with the dreaded aliment, due in large part to the clean mountain air, which provided an excellent environment for recovery. Margaret Del Rosso, Marian's sister, moved to Asheville to help run the facility shortly after the purchase. Both of the sisters were nurses and set up the home to attend to as many as eighteen patients at one time. Marian was lovingly referred to as Miss B by her patients. No new patients were admitted to the facility after 1955 after Miss B suffered a heart attack. The last patient moved out in 1967, at which time Marian's only son, Charles, along with his wife moved into the home. Charles died in 1979 and his wife, Caroline, lived there with their daughter until selling the home to Howard Stafford in 1995.

The current owners and operators of the bed and breakfast, Frank Salvo and Ralph Coffey, moved into the home in 1999, having relocated from Charlotte, North Carolina. Frank has told me that when they first started doing the renovation work they would hear all types of strange noises and simply chalked it up to being an old house. After the remodeling was complete, Frank said that it was obvious that the noises were much more than just the standard creaks and groans of an old structure—they were those of an inhabitant from the spirit realm.

Guests commonly ask who the kindly looking elderly woman was that had visited them the night prior. Dressed in a floor length black dress with her gray hair pulled into a bun, she has also been

spied in the hallways and in the gardens. Many assume she works at the bed and breakfast, but think it odd that she did not knock before entering the room. Odd indeed! Marian has always been reported as being very sweet in her facial expressions and gentle in her movements. Much as she did in life with her patients, she likes to watch over the guests and make sure their needs are being fulfilled.

A few years ago her energy field was documented in a short video at the home by a paranormal researcher. It was with this video that I was able to experience firsthand the ghost of Marian Bridgette. While watching the video I sensed a presence behind me. As I turned around to see who was there, she passed through me, leaving me chilled in what had been a very pleasant temperature. Upon turning back around, Frank was sitting across from me with a grin upon his face. Before I could say anything, he said that it was Marian, who apparently enjoys watching the video of herself, and he could sense her as he had done many times in the past.

Frank and Ralph decided to hire a medium to come in and to do a reading of the property. They did not inform the medium of any of the history of the place, so as not to taint the findings. Not to their surprise, the medium reported that one of the spirits in the home was that of a woman named Marian. They were told that Marian had been a nurse and cared for many in the house for a very long period of time. She dearly loved the home and felt the need to complete her task of caring for the inhabitants who visited there.

In addition, to Frank and Ralph's amazement, there are two other residents of the paranormal type residing there. One goes only by the name of "Colonel." The medium was unable to glean any additional information concerning the Colonel, only to say that he was a very sad and unhappy spirit.

Frank believes that the spirit may be that of Marian's only son, George, who lived there until his untimely death in 1979. Frank thinks that George served in the army and may have been a colonel.

The second being is the spirit of a man who hung himself many years ago in the basement. He is also unknown by name but was most likely one of the many hospitalized there when the house was a sanitarium.

Both of the other spirits apparently do not make themselves known to the guests of the inn, but only to the owners and staff. They not only hear strange noises coming from the basement, but also frequently report items being rearranged on the shelves or items thrown onto the floor.

The 1889 Whitegate Inn and Cottages are always busy during the tourist season, with little wonder. It is truly a breathtaking bed and breakfast made even more interesting by the extra amenities afforded to the few lucky guests looked after by the kindly Miss B.

For a lifetime memory, come and stay at the Inn. There is no extra charge for Miss B's service!

The Ghosts of Church Street

The three oldest churches within the city limits reside on the corner of Aston and Church Streets in Asheville.

The Central United Methodist Church was originally erected in 1837 as a wood-frame building; however, the current building was constructed in two phases, the first in 1902 and the last in 1905. J.M. Westall, uncle to Thomas Wolfe, constructed the structure that is both Gothic Revival and Romanesque Revival.

Directly across the street is the First Presbyterian Church. Meeting in a wood-frame building, it dates back to as early as 1794, but the current brick edifice was constructed in 1884–1885 at a staggering cost of eight thousand dollars. At that time, it housed over six hundred worshipers, but many additions and enlargements have been added over the years to accommodate the ever-growing congregation. The style is classic Gothic Revival.

On the corner of Church and Aston Streets is the large brick structure that houses the Trinity Episcopal Church. Originally, services began around 1865 in a wood-frame building with the current church being built in 1912, and several additions have been built since then. Its style is classic Tudor Revival and was designed

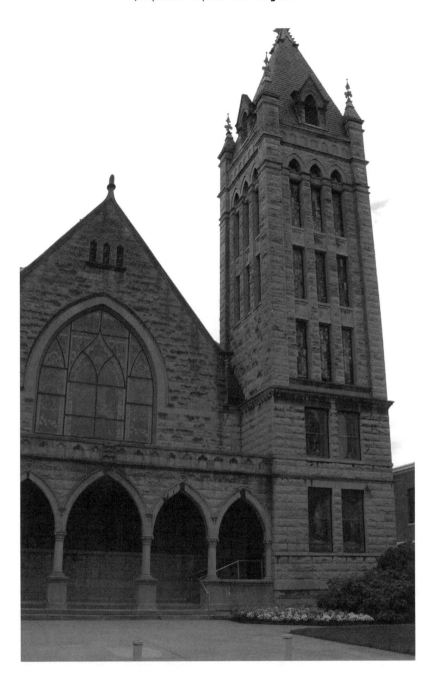

by the nationally known architect Bertram Goodhue.

To view these churches in person is awe inspiring, as they form a quite formidable view for almost a two-block distance. All three have New England slate roofs with a tremendous amount of copper detail. With their Romanesque, Gothic and Tudor Revival styling, the churches transport one back to times long gone and are particularly eerie after dark.

There is another, paranormal reason the churches are interesting: all three of the churches originally used their property for burial of their members. The burials were discontinued when Asheville passed the ordinance forbidding burials on public or private property. The churches were not required to remove graves that were already on the property, but slowly did so as the need for building expansion became necessary. Most of the graves were relocated to cemeteries in the area.

Well, they may have removed the coffins and the bones within, but they failed to remove the spirits of the buried.

As mentioned previously, oftentimes when parishioners were very attached to their churches in life, their spirits will remain at the church where they worshiped. Such is the case with this area, for it is the most concentrated haunted area in all of Asheville.

On any given night, there is always a great deal of paranormal activity on the street. Some nights the activity level is average, but on many nights the level goes off the scale.

The church with the most unusual activity is the First Presbyterian. There lies within the structure a black abbey, a type of spirit connected with churches. Why and what they are, or were, can only be surmised. My personal opinion is that they are female by gender and most likely had once been directly connected to the operation of the church.

A longtime maintenance man at the church reports that on a very frequent basis he sees the black abbey. He works the late shift and does not finish his duties until about midnight. He said the first time

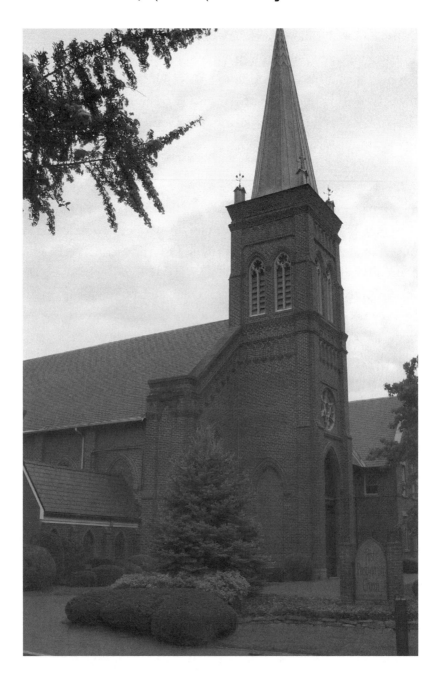

he experienced her was almost his last time. He had been working at the church for about six months when one evening, while doing his normal duties, he was almost knocked off of his feet. He was instantly chilled, even though it was summer, and he had observed no one in the area.

Thinking it odd that a wind powerful enough to knock him down could blow through the open windows, he went to investigate if there was an approaching storm. To his amazement it was a cloudless night, filled with many stars.

Returning to the task at hand, he was perplexed. Diligently working at repairing a light, he was absorbed in the moment, and only at the last split second did he observe a black shadow rapidly approaching him, passing through his body. Instantly, the same sensation of cold was upon him.

This time he fell backwards to the ground completely on his own volition. Now, assured that he was going crazy, he squirmed around on the floor trying desperately to regain his ability to stand upright. Upon rising he needed the support of the wall to remain erect and fearfully looked about him to see if he was about to be revisited. After many minutes he decided that he was once again alone, clocked out and went home.

At home he decided that a shot of Kentucky bourbon would help calm his nerves and to allow him the peace of mind to think through what he had just experienced. Coming to the conclusion that he was indeed not crazy, he decided he had actually experienced something of a paranormal origin.

Surprisingly, he said that he was not that terribly frightened by the event after analyzing the situation. He returned to work and has now come to accept the black abbey as a part of the church. She, in turn, no longer interferes with him or his job.

There was a period in September 2004 when the black abbey was seen and filmed several dozen times by guests of Haunted

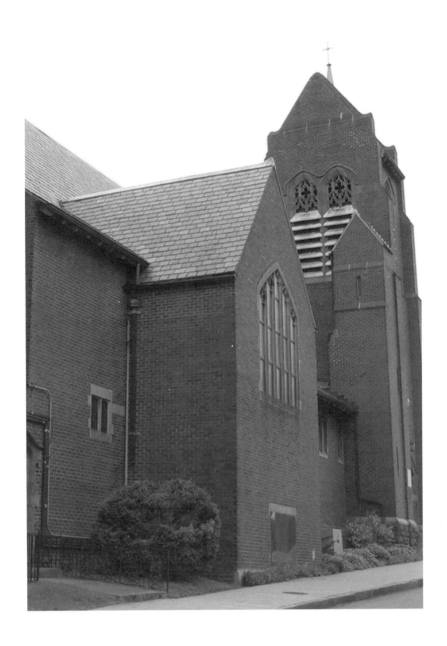

The Ghosts of Church Street

Ghost Tours of America. Much to their fright, she was seen fleeting from window to window and from floor to floor. Appearing as a black image, she seemed to be as curious about the spectators as they were of her. This phenomenon went on almost every night for a ten-day period.

On another occasion, a young girl on the tour was leaving the First Presbyterian Church with her parents and other guests. As they were heading to the next stop, she turned around and took one last picture with her digital camera of the area where they had just been standing. Running, she excitedly approached the guide to show him the picture she had just taken. What everyone observed was the unmistakable image of a woman dressed completely in white. As if a very powerful spotlight had been placed behind her, the woman in the picture emitted a brilliant white light. She was also holding a white cross out in front of her.

Across the street at the Central United Methodist Church, there have also been many exciting pictures taken of some rather unusual spirit orbs. Around the corner on Aston Street sits the similarly haunted Trinity Episcopal Church. It has been obvious from many pictures taken there are many souls that remain near the church they so dearly loved in life.

On your next excursion to the downtown area, take a drive down Church and Aston streets late at night and see if you can sense anything out of the ordinary. Or better yet, go on the Haunted Ghost Tour and hear the legends of the area and get a lot of paranormal pictures. By the way, say hello to the Black Abbey while you are there.

The Ghosts and Legends from the Will Harris Murders

In November 1906, Asheville experienced one of those rare, unforgettable events in its history that became the basis for legends. It was a night of murder, mayhem and horror—the kind one reads about in order to satisfy some sort of morbid curiosity and hopes never to have to experience personally.

The actual story of Will Harris, the soul responsible for this violence, is that of a strange African American man who sauntered into town one cool November day in 1906. He headed to a pawnshop, where he made what seemed a very strange purchase of overalls, a pair of high-topped bright yellow shoes, a high-powered Savage rifle and ammunition. He attracted no undue attention to himself during the first part of his short-lived stay in Asheville, and his odd purchases were among the bare bones amount of information uncovered by later investigation.

On November 13, a call was placed to Asheville police asking them to investigate a disturbance by a man at a small apartment just off Valley Street.

Captain J.L. Page and patrolman Charles Blackstock responded to the call, and upon arriving, the reported man exploded into a violent rage, obviously driven in part by a drunken stupor. Without any warning, Will Harris reached inside the front door of the apartment and withdrew his newly purchased Savage rifle. He severely wounded Captain Page and killed patrolman Blackstock.

Seemingly not satisfied with these actions, Harris took off and headed a few blocks away from the crime scene to Pack Square. There patrolman J.W. Bailey, knowing that Harris was armed and dangerous, ducked behind a large wooden telephone pole and opened fire with his Smith and Wesson service revolver.

Harris whirled around with the agility of an animal in the wild toward Bailey. He raised his Savage rifle and fired once at the post. The thick pole was no match for the high-powered bullet that easily pierced it and instantly killed patrolman Bailey.

Now like a vampire lusting for more blood, Harris began running in the direction of Biltmore Avenue, firing snap shots at anything that moved. An elderly man, hearing all the commotion, raised the window in his apartment to peer out. With a marksman's deadly accuracy, Harris sent a bullet directly between his eyes, killing the old man instantly. A neighborhood dog appeared at the mouth of an alley, and the desperado, with unerring aim, put a slug into the hapless animal.

By the time Harris got out of the city, five persons—two policemen and three African Americans—had been murdered that tragic day. The citizens of Asheville were stunned as the news spread like wildfire.

After the initial shock came the swift reaction. The angered citizens organized into a posse, many of them on horseback.

As the hours passed, the rumors concerning the incident began mounting to a huge volume. It was determined that most likely Harris had fled south out of town on foot. Leaders of the posse cautioned the group's more reckless members against any type of foolhardy action that would place them within killing range of that deadly Savage rifle.

At long last, a report came in saying that Harris had slept in a barn near Buena Vista and had been seen leaving by a gentleman named George Frady.

Frank Jordan, an experienced police officer, had better organized the manhunt. He decided to break up the group into smaller posses to handle the situation. The groups set out, heading towards South Asheville, becoming more and more excited, anxious and fearful of the impending confrontation. Some spoke of lynching, while others spoke with bravado of other punishments befitting an animal. All the while, each one of them had to be wondering if he would be the next victim of Will Harris.

On November 15, the finale was at hand. As the groups approached Fletcher, just south of Asheville, they located Harris on a large tract of wooded land on the Westfeldt place. Slowly approaching, the members of the posse closed in, ever vigilant of the snarling repeats of that Savage rifle.

It was a fearsome battle, with Harris hellbent on taking some more poor souls with him to his doom. Finally, to the relief of everyone in pursuit of Will Harris, he ran out of ammunition. Defiant to the very end, Harris's body was riddled with bullets.

The body was returned to the Hare, Bard and Company funeral home on Biltmore Avenue, where witnesses to the massacre identified the sorrowful remains of Will Harris as those that had committed the heinous acts.

As was the custom of the day, the Savage rifle was presented to Captain Page, the first victim of the spree, and the reward

offered by the state of North Carolina and Buncombe County was unanimously voted by the members of the posse to be given to the widows of patrolmen Bailey and Blackstock.

As far as the public was concerned, this brought the event to its ultimate violent conclusion, and the books were closed forever.

Little did anyone realize that this was only the beginning of what was to be the start of an ongoing set of paranormal events that would last for all eternity.

The pawnshop where the story all began is located on Biltmore Avenue and is now a taproom and eatery. To this day, both staff and patrons commonly report many strange events. Unexplained sounds, voices heard that take on a ghostly tone, a service elevator that operates on its own and many other events are just a small part of the phenomena due to the Will Harris murders.

Staff will often report being tapped on the shoulder by someone behind them and, whirling around to see who it is, are greeted with only blank space and a cold chill. Members of the wait staff also hear voices behind them, whispering a name or some undeterminable word, when there is no one around to speak to them.

Loud noises often emit from the kitchen area, including breaking dishes or falling pots and pans. When investigated, nothing seems out of place.

Is it Will? Is it one of victims crying out for attention? You decide! One of the policemen who was killed that fateful day can still be seen from time to time, running down Biltmore and Eagle Streets as if trying to either elude or apprehend Will Harris.

Many also report the three African Americans massacred by Harris can be seen in the vicinity of their demise. Often heard is the sound of a howling dog in the alleyway where Harris killed the hapless animal, but there is never a dog present at the time.

What brought a man like Will Harris to start a series of events that would live in infamy? Some believe he had become intoxicated

and flew into a jealous rage over the woman he was staying with in the small apartment where he was first found. Others feel he came to Asheville with every intention to commit the atrocities he performed, and still more believe he had to be insane or at the very least mentally unbalanced.

When visiting downtown Asheville, walk the streets of Eagle and Biltmore Avenue, so that you to can get a sense of the violence that occurred there so long ago. When the hair on the back of your neck rises and a cold chill is in the air, step up your pace a little bit, for Will Harris may just be looking for his next victim.

The Haunted House of John Patton

One of the first families to settle in the Asheville area was that of John Patton. From all indications, John Patton was born in Virginia on April 6, 1765. He married Ann Mallory, born February 12, 1768, also from Virginia.

From scant records it appears that descendants of John Patton moved to the western North Carolina area during the Revolutionary War. Sparsely populated by any white settlers and mostly inhabited by Cherokee Indians, it was a rugged and dangerous lifestyle at best.

By the late 1790s, Asheville had grown to about two thousand people, and the opportunities to make money were abundant. John Patton saw the need to educate the young boys and men of the community and opened up an academy near the outskirts of Asheville on Main Street.

Not far from that area runs the Swannanoa River in Buncombe County. Perched upon a high bank along the river, John Patton built

a large two-story wooden structure with three brick chimneys. The design resembles that of a saddlebag: two long wings connected at one end. The roof is a shingle type, with six-over-six windows. It was a most imposing house indeed.

Life became somewhat calm following the years when they first moved to the area, then considered mostly a wilderness. The academy flourished as the population continued to grow

and, of course, Asheville became the center of life for western North Carolina.

John and Ann had twelve children, as was the practice of the day. One of these children, Lorenzo Dowe Patton (born May 20, 1804) married Rebecca Love on January 3, 1828. In 1829, they gave John and Ann a grandson, named John D. Patton.

Now that you have the basic facts of the family, let's find out how this family home became a haunted house.

John D. Patton continued to operate the academy and eventually moved into his grandfather's home. It was at this time that many strange events started to occur. John D. began telling of noises that would awaken him in the middle of the night. When he went to investigate there would be nothing there.

On one occasion, he awoke with a start to the sound of his own name being called out from the foot of his bed. He observed a whitish puff of smoke that looked exactly like his deceased mother, Rebecca. She stood there, reaching out her hand and softly speaking his name, but she would not respond to his calls. John D. said he arose and approached her. When he reached out to touch her hand, she simply disappeared. He felt he was going insane but soon realized that it was not his imagination: his mother was, in fact, visiting him.

The visits continued for many years on a somewhat regular basis. Sometimes his mother would gently call out his name. At other times she would simply stand beside the bed smiling at him, much as mothers tend to do when pondering the wonders of their children.

Apparently satisfied that her son was going to be ok, she departed after a number of years and many visits, most likely for the other side to reach her final destination.

In a short while, other strange events started occurring. John D. reported shortly after his mother's last visit that someone else made

his or her presence known. His first indication was that the door leading into the cellar would open and close repeatedly, with no one ever being there to operate it. John D. stated that by this time he was not frightened by such occurrences, due to the visits from his mother.

John D. was never quite sure who the newest apparition was, but felt like it was possibly his grandfather, John Patton. Other events included the lighting of candles in the middle of the night, something his grandfather used to do when he was alive, as he never slept well and would stay up late and read.

There were many other spirits that followed over the years, as if his mother's leaving for the other side had created an opening that allowed other entities to enter this realm.

One of the more interesting characters that came through was his father's sister, Harriet Dorothy Patton. She appeared about 1860, just prior to the Civil War. Being a spinster all her life, she was also known for her strict discipline and tidy ways.

She apparently did not agree with the way John D. kept his home, for often he would find rooms rearranged. At first he found this to be a very irritating intrusion into his domain, but soon realized that until his aunt Harriet felt the need to return to the other side, he was doomed to her ways.

Aunt Harriet also loved to teach overnight visitors how not to simply toss off their day clothes onto the floor when retiring for the evening. Many a guest reported that in the morning they awoke to find their clothes not only picked up, but also neatly folded and resting upon the dresser. Very few of these guests ever returned for a second visit.

Aunt Harriet continued her vigil over the Patton home until around 1870, when she suddenly disappeared. John D. notes that this most likely occurred because she finally gave up on trying to change his untidy lifestyle.

The Haunted House of John Patton

Upon John D.'s death, he was interred along with many other members of the Patton family in Newton's Academy Cemetery in Buncombe County, North Carolina.

The house remains today, although in disrepair, on that high bank alongside the Swannanoa River. It is simply referred to as the "Haunted House" these days, for good reason. It has been the site for many to come and have their wits scared out of them. Apparently, many of the Patton clan still frequent the old house, including John D. Those who dare to venture to the haunted house often get a whiff of John D.'s cigar smoke wafting from the front porch. The curious are often greeted with cold winds blowing on a warm summer night or the unmistakable sound of a voice in what is obviously an empty structure.

Few have ever been reported to enter the old house, and it is said those who have exit as white as ghosts (no pun intended) and never return to the place again.

If you are bored one evening, take a drive out on the Swannanoa River to the Patton Haunted House. There you can see what the spirit realm is all about, but don't blame me for the results.

The Legend of Sneed and Henry

An event occurred in Asheville on May 29, 1835, that shook the very core of many of its citizens.

It was the year of Asheville's centennial. James Sneed and James Henry were arrested on the charge of the highway theft of a horse, a capital crime at the time. The victim of the crime was a Mr. Holcombe, whose farm was located about six miles east of downtown Asheville. Sneed and Henry, fearful that Mr. Holcombe would have them arrested, started out for Tennessee. They did not make it very far and were arrested in Sulphur Springs, North Carolina, by Deputy Sheriff Shep Deaver.

The trial was short and sweet. Both men were found guilty and sentenced to death by hanging. The execution of Sneed and Henry was to be the third such event in Asheville's brief history. This caused a great deal of excitement in the county, as had the two previous hangings.

A young lad named A.T. Davidson wrote an account of the hanging. Determined to attend this gruesome event, he set out toward Asheville two days in advance, although he only lived twenty-five miles away. There were no paved roads, and most people could

not afford horses in those days, so walking was the only other choice of transportation. A.T. met up with a number of friends along the way, and together they formed a sizable group.

Upon reaching Asheville the day before the execution, A.T. and others set out to view the goings on at the place of the hanging. There were three men at the gallows tying the noose and testing the double swing out trap door in the floor. When satisfied with their efforts, they slapped each other on the back and took off for parts unknown.

Governor David Swain came to Asheville as part of his official duties and was beseeched by many of the local citizenry to pardon the two men for such a minor crime. He suddenly disappeared from town the day before the execution and was censured for leaving by those seeking a respite or pardon for Sneed and Henry.

The gallows field stood near where Merrimon Avenue and Broadway merge today. On May 29, 1835, between five thousand and eight thousand souls were present to witness the execution. There were two long sermons that were delivered that day, both given with great excitement and the utmost intensity, more for the relief of the living spectators than for the condemned.

At about two o'clock, there was a great clamor from down the road. It was a wagon with Sneed and Henry seated upon their coffins, surrounded by the military and followed by several thousand spectators. They drew up to the foot of the gallows, and several men mounted the gallows along with the prisoners.

The prisoners were given the opportunity to make any remarks they desired, and Sneed spoke first. He was a bright-faced, clean-shaven, fine-looking young man, with a distinct voice that could be heard at a distance without effort. He said that he had been a wild, wicked young man. He claimed to be an adventurer who made money by every means available. While not slow to use his penchant for tricks at cards to procure money from the ignorant

and unsuspecting; he felt he had done nothing to deserve death. He had never taken a life or another man's property by force. He said it in a clear, ringing voice and attracted general sympathy.

Henry came on the scene, a heavy-headed, thick-shouldered and strong man. He gave the impression to the crowd that he was a person capable of committing any type of crime. Henry called for the victim of the crime, Mr. Holcombe, to approach the gallows. Mr. Holcombe fought his way through the crowd to the front edge of the gallows, and Henry made a statement in his presence as to how he had obtained the horse. He asked Holcombe if that was not the way it had been and Holcombe denied it, stalking off sulkily without stating his own version of the story.

Then came the end. The black caps were drawn over their heads of the two men. The sheriff and his deputies bade the men goodbye and stepped off of the gallows. The signal was given and the trap was released. For just a second, something unusual happened. The trap doors did not open completely and seemed stuck part way down. Sneed and Henry's feet both danced desperately on the partially opens doors trying to cling onto every moment of life. But to their despair, the doors flung completely open and the men plummeted, the full weight of their bodies dangling helplessly from the torturous ropes that were digging their way into the criminals' flesh.

Then began the death struggle. They both spun round and round. There was a drawing up of the shoulders and of the arms, both dying of strangulation. Then the tremor of the bodies started, then the rush of blood to the hands, tied behind them, making them swell to hideous proportions. At long last the bodies hung still. Sneed had died first and Henry, second.

Alas, dear reader, you could not possibly be thinking that this was truly the end of the event.

From the moment Sneed and Henry were buried, they became active in the spirit community. The man who had accused them of the theft, Mr. Holcombe, did not live a very pleasant life from that time forward, often complaining about terrible nightmares concerning the hanged men. He said they often would come and visit him in his sleep, asking repeatedly why he had not told the truth concerning the horse. He said it appeared as real as anything in life and became convinced that their visits were real. Holcombe died an untimely death in a plowing accident on his farm some years later.

Many people began to think that perhaps Holcombe had not told the truth about the two men, and this was his punishment for lying and causing Sneed and Henry's death.

In the area of the gallows and at their graves, located some sixty feet away, a sound of an unusual nature has been reported on a regular basis. Many have likened it to that of a trap door of a gallows. Also heard often is the sound of a horse-drawn wagon, the hoofs of the horses clopping and the steel-clad wheels grinding along the road, followed closely by the commands of a military leader to his men.

Sneed and Henry were not prepared to die that day and felt unjustly convicted. Hence, they have remained in the spirit realm and will stay there forever, unless fortunate enough to cross over one day to the other side.

If you feel compassionate enough to want to help these poor souls make their final journey, then by all means, go to the old gallows fields late at night and ask for Sneed and Henry to make their presence known, so that you can help send them on their way.

The Spirits of the Battery Park Hotel

Across from the famous Grove Arcade, between the corners of Page and O'Henry Streets on Battle Street, sits a brick-clad building. Known as the Battery Park Apartments, now a retirement home, it was originally the Battery Park Hotel. Constructed in 1924 by Dr. E.W. Grove of Grove Park Inn fame, it was considered to be one of the finest hotels in Asheville.

Before the current structure was built, a huge wooden resort hotel by the same name rested at the location. So large was the resort that it covered twenty-five acres and was built by Colonel Frank Coxe in 1886. The hotel featured such fine amenities as a fireplace in every room, baths on every floor, modern steam radiators and Thomas Edison's newest invention, the electric light bulb. Twice a week, little girls in patent leather shoes and starched white dresses arrived at the hotel ballroom to be taught the elegant art of dancing by none other than Arthur Murray, the hotel's instructor. The Battery Park Hotel boasted of such guests as Grover Clevland, William McKinley, William Harrison, Teddy Roosevelt and Franklin Roosevelt.

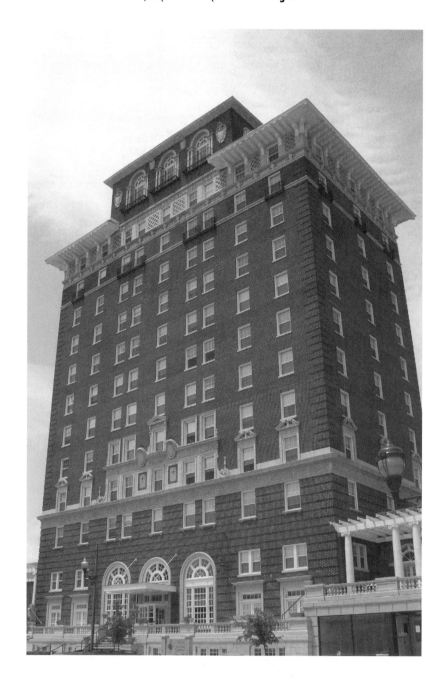

The Spirits of the Battery Park Hotel

When E.W. Grove purchased the old hotel it was in a state of disrepair, and instead of renovating, he decided to demolish the structure. Shortly after the demolition began, a fire broke out and the remains were burned away in a matter of a few days.

The guest register of the new hotel often included Lou Gehrig and Babe Ruth, the famous baseball teammates. One story is told that Lou came running into the hotel looking for a room key. He was followed by four of his teammates carrying a drunken Babe Ruth. "He was as long as a sofa and red as a boiled beet. They were all laughing, the Babe passed out, and they carried him like a log," reported the desk clerk. Later that same day the Babe hit a home run. Not much has changed in professional sports since then; they just hide it better today.

F. Scott Fitzgerald stayed at the Battery Park Hotel during his wife's treatments at Highland Hospital.

It is said the George Vanderbilt, while staying at the hotel, looked south from the veranda and noticed a giant pine tree in the distance, standing above the rest. He told friends that day that was where he planned to build the Biltmore Estate, and it came to pass.

As you can see, the hotel has had a very illustrious past, but it also has had it share of tragic events, including the suicides of two men. A forty-six-year-old man in 1943 and a twenty-eight-year-old man in 1972 both dove 150 feet to their deaths from atop the hotel.

Although not of a tragic nature, E.W. Grove, the builder of the hotel, also died there in 1927.

The most tragic event was the brutal murder of a young nineteen-year-old girl by the name of Helen Clevenger on July 17, 1936.

A professor by the name of W.L. Clevenger was staying at the hotel during a business trip to Asheville. His niece, Helen Clevenger, had come down from New York City, where she was attending college, to visit with her uncle and to see Asheville and its surroundings. On the morning of July 17, W.L. Clevenger went to Room 224 to

awaken his niece for breakfast. He knocked on the door, but there was no response. He tried again, but still no answer. He then tried the doorknob, and it easily opened. He decided to step in to see if Helen was indeed still asleep or had just stepped out for a moment but quickly exited the room back into the hallway.

W.L. was in shock, not sure of what he had just witnessed. A staff member of the hotel was working in the hallway at that moment and, noticing the astonished looked upon Mr. Clevenger's face, asked if there was anything wrong. W.L. could only mumble something about come-and-see-what-they-had-done-to-his-niece. As members of the staff rushed into the room, they exited just as quickly as W.L. had, some in shock and others retching.

What they had all witnessed was poor Helen's body laying on her back on the floor, legs twisted underneath her. She was lying in a very thick pool of drying blood, having been shot once with a .32-caliber pistol in the upper left chest area, and her face and throat had been slashed and beaten with some type of sharp object.

There was a staff member by the name of Durham Jones on duty the previous evening who later reported that he had seen a man dash past the open door of the service room where he had been sitting. He said that it was storming outside and it made the hallways dark and difficult to see exactly who it had been. He did see the figure duck into the General Manager Pat Branch's office. Durham said he crept down the hallway and peered into the office window to see who it was. Spotting nothing, he turned around to head back to the staff room when he heard a door shutting at the back of Mr. Branch's office. He dashed to a hallway window to, once again, try to see who it was. He reported that it was a man, appearing to be about 160 pounds and approximately 5'8" or 5'9" tall. He said the man jumped over a railing and dashed down the street, off into the darkness and heavy rain.

A number of possible suspects were either temporally arrested or questioned concerning the heinous crime, but all were released. It took almost thirty days for the Asheville police to finally make an arrest with charges.

They arrested a twenty-two-year-old man named Martin Moore. Martin was also an employee of the hotel and had been on duty earlier that evening. The police reported that Martin finally provided them with a written confession of his deeds. The police also found a .32-caliber pistol tucked away in the bathroom of Martin Moore's apartment. The pistol had an unusual protruding point from the heel of the grip, and the police claimed this is what was used to slash and mutilate Helen Clevenger.

Martin supposedly claimed in his confession that he had set out that evening to rob one of the guest rooms for some quick money. He had tried several doors on the second floor of the hotel, but all were locked except for Room 224. He slipped inside, feeling that the guest had gone out for the evening and this would be an easy room to rob. But much to his surprise, he stated, Helen was startled from her sleep. She yelled out asking what he wanted. He stated that she approached him and, fearful of detection, wrestled with her briefly before shooting her once. The shot did not kill her immediately, and she began to scream in terror and pain. Martin stated that he then took the butt of the gun and brutally beat her about the face, slashing her throat with the protruding point from the grip.

At the trial, the coroner stated that Helen would have expired in three to five minutes and suffered greatly from her wounds.

Martin Moore was executed in the gas chamber in Raleigh, North Carolina, for his crime.

Sounds like the end of the story, doesn't it? Not by a long shot.

Many in the community believed that Martin Moore did not commit the crime. He was a much bigger man than that described by Durham Jones on the night of the murder. Despite the written

confession, which could have easily been forced by the police, Martin had maintained his innocence right to the moment of his execution. Being slightly retarded, Martin had never shown any type of violent nature. Because of this, many believe that the true murderer that night was Mr. Branch's son who had been working at the hotel that summer for his father. The son disappeared on the night of the murder and was never seen or heard from again in Asheville.

Many citizens of Asheville feel that the police were under a great deal of pressure to solve this vicious crime and chose to make Martin Moore a scapegoat.

By now, you already know that this is truly not the end of this story.

Many strange events continue to occur at the old Battery Park Hotel. Often reported are the apparitions of what is believed to be that of E.W. Grove, walking the hallways, as if surveying his beloved hotel. Also commonly seen is a spirit of a young girl, most assuredly that of Helen herself. She generally appears in what was once Room 224.

The current residents of the retirement home report windows and doors opening on a regular basis and often hear the sounds of someone running down the hallways.

The most interesting occurrence happens every July 17, the anniversary of Helen's murder. If you stand on the street and photograph the area that had been Room 224 very late that night, you have an extremely good chance of capturing a unique phenomenon. Look at your pictures closely when developed or downloaded to your computer, and you will most likely see that one window has a red glow around it. Most feel that it is Helen herself that makes this occur, reminding the world of her tragic death.

Although currently only residents are allowed inside the old Battery Park Hotel, when in Asheville make a point to stand outside the old Battery Park Hotel to sense all the spiritual phenomena.

The Ghost and Legends of Shiloh

George Vanderbilt, of Biltmore Estate fame, is indirectly responsible for creating this next legend.

Mr. Vanderbilt had a great interest in horticulture, and he hired Richard Olmstead, the world famous landscape architect, to landscape the estate. Upon arriving at Biltmore, Olmstead set off on horseback with his assistants to survey and access the property. When he returned some days later, he informed Vanderbilt that even he "did not have enough money to landscape the entire one hundred twenty-five thousand acres."

Olmstead did persuade Vanderbilt to consider establishing a team of experts to help nurture and preserve the forest that filled virtually every square foot of the property.

With Olmstead's help, Vanderbilt solicited American forester Gifford Pinchot and world-renowned European forester Sir Dietrich Brandis. The person selected for the job was Dr. Carl Alwen Schenck, a famous German forester.

In 1895, Schenck moved to North Carolina to take over the management of the forest from Gifford Pinchot.

The Ghost and Legends of Shiloh

With George Vanderbilt's permission, The Biltmore Forest School (BFS) was opened in 1898 under Dr. Schenck supervision. BFS students were initially sons of wealthy lumber and timber barons. In its fifteen-year history the school would graduate over four hundred forestry students, and they in turn introduced scientific forestry techniques throughout North America.

Unfortunately, Dr. Schenck closed the school in 1913 due to low enrollment. Although very skillful as a forester and teacher, Schenck had a quick temper and demanded a hands-on, practical forestry school. He felt that his approach would attract students, but, alas, it did not. His temper cost him his position at the estate and dissolution of the Biltmore Forest School.

Vanderbilt purchased from Hiram King a house that he turned into a ranger's house and built a commissary in 1902 for the men that maintained the school and the forested areas. There are other buildings on the compound to this day that are now long abandoned.

Our legend has its roots in these abandoned buildings. Dr. Schenck died in 1955 at the ripe old age of eighty-seven. To his dying day Dr. Schenck held animosity towards George Vanderbilt for firing him and closing down the school. He felt that Vanderbilt had unjustly taken these actions against him as a personal vendetta and vowed to get even somehow.

After Schenck died many strange events occurred at the old compound called Shiloh. The local area residents started seeing lights come on in a few of the old buildings and wondered who was in there with a flashlight late at night. Several times the local sheriff came out to the property to investigate who was entering the compound, but no one was ever found.

One local resident, driven by curiosity, decided he would solve the mystery and went to see for himself who was there. He crept up to the boarded up building and tried to peer inside.

He could see the light, but there was no source for it. He was bent over slightly to look through one of the cracks when all of a sudden someone or something tapped him on the shoulder. Spinning around in total fright and nearly falling down, he spied a dark shadow towering over him and felt a very cold breeze even though it was a warm summer evening.

Ashen white and unable to scream because of his extreme fear, he stumbled several times in a feeble attempt to escape. Unable to feel even his legs at this point, he somehow managed to make some forward progress towards home. He reported later that the large black image continued to lurk over him, followed constantly by the cold wind, until he finally and blissfully reached the edge of the compound.

Needless to say, the man never returned to the compound, and as a matter of fact sold his own place shortly after that. The curious man disappeared like a puff of smoke on a windy day, never to be heard from again.

The abandoned building is a long two-story affair, now boarded up. Over the years, kids have made their way into the structure, but most never stay for long. They report that the downstairs consists of a long dark hallway with doors alternating on either side. In one of the downstairs bathrooms there is a toilet that is lined with dried blood.

Upstairs there is a room that was used by a now dead prostitute. The building now has the unenviable moniker of "Whorehouse" for that reason. It is said that you can still hear the voice of that "lady of the evening" singing softly some type of lullaby.

One sure sign of the presence of many spirits in the building is the fact that it never seems to reach over forty degrees, even when it is hot outside.

The building has a length of rope still hanging from one of the rafters, complete with an expertly tied noose on the one end. Legend has it that the structure was the site of a lynching in the late 1950s of a poor soul accused of God-knows-what, and he still haunts the property, most likely seeking his revenge upon his executioners.

There are other buildings in the compound area that are just as haunted as the long dormitory building. Still reported to this day is the fact that doors throughout Shiloh will simply open and then

slam shut and lights turn on and off, all for no obvious reason and with no one in sight.

It is almost as if the spirits are beckoning their next unsuspecting soul to the place, extracting whatever pleasure they can from terrifying their hapless victims.

The Biltmore Estate Legends

When George Vanderbilt brought his mother to Asheville in 1888 to give her some relief from a respiratory problem, he stayed at the Battery Park Hotel. It was from the veranda of the hotel that he first observed the area to the south that would eventually become his dream, Biltmore Estate.

Vanderbilt dispatched a team of New York lawyers to the area, and they discreetly started purchasing up all of the land in the area. Not wanting any of the landowners to know for whom or for what purpose the land was been purchased, the lawyers bought the property in each of their own names, so as not to drive up the price.

When they had purchased 125,000 acres, the properties were then transferred into George Vanderbilt's name.

There had been a great deal of speculation and rumor as to the purpose of this "gang," as they came to be known. When Vanderbilt informed the citizenry of his intentions to build Biltmore, there was a collective sigh of relief. Instantly, everyone could see the benefit of having such a place and such a person as a Vanderbilt come to Asheville. At the time the citizens of Asheville had no idea of how

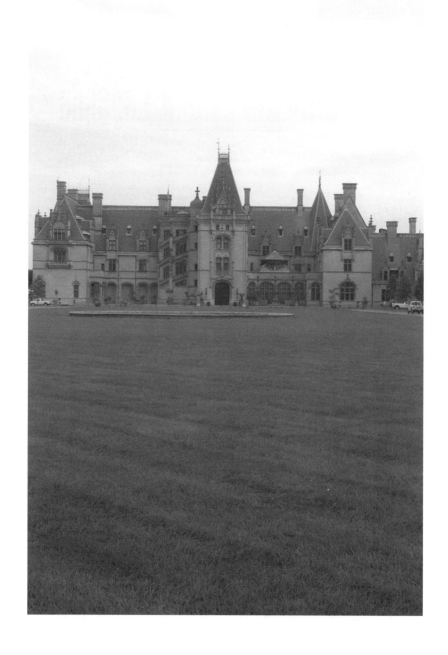

The Biltmore Estate Legends

correct their assumption would be. Construction on the magnificent home began in late 1889.

Considered America's largest home today, it contains some 255 rooms, all decorated in the very finest of materials available at the time: the best antiques, tapestries, art, glassware, crystal, silver and gold ware.

Vanderbilt, not being inclined towards business like his siblings, was a patron of travel, the arts, literature, architecture and horticulture. He was the youngest of the Vanderbilt heirs and received the smallest inheritance, only 6.5 million dollars in the 1880s. By today's value that is equivalent to approximately 400 million dollars. Not bad for the smallest inheritance.

Vanderbilt's dream was to outdo his siblings and other relatives in building the largest and grandest of mansions. He won, hands down.

He officially opened the home on that Christmas Day of 1895 by bringing all of his family, relatives and friends to Asheville in grand style, and had them escorted to the Estate by white horse drawn carriages. The procession stretched as far as the eye could easily see.

Vanderbilt's dream was to establish the estate in the fashion of the grand European estates, making Biltmore totally self-sufficient and profitable. To this end, George Vanderbilt built a dairy, a complete village near the estate to house his twelve hundred-member staff, schools, churches, a library, a medical clinic and a winery.

Unfortunately, George watched his fortune dwindle away almost to the point of bankruptcy, never realizing his dream of a self-sustaining estate.

Due in large part to the stress he felt from his financial woes, he died suddenly in 1914.

Fortunately for the rest of the world, his wife was a savvy businessperson and sold off 117,000 acres of the estate to the federal government in 1917 for a large sum of money. It is now in the national park system as Pisgah National Forest.

The descendants of Vanderbilt, born from his only daughter,

Cornelia, who married a local businessman named John Cecil, now run the home as a museum.

Over one million visitors tour the home annually, and more than one of them have had a very special added attraction on their tour.

George Vanderbilt so loved his home that he has remained there ever since his untimely death. Seen by many visitors over the years, he will make himself known when he wants to show off his beautiful house and all of its possessions. He is reported often as seen in the foyer of the home as if waiting to greet his visitors.

A member of the staff relays the story of how he personally met George Vanderbilt during the start of the Christmas holiday season some years ago.

The gentleman was going about his normal routine of setting up the Christmas decorations one late afternoon when the house was closed to regular visitors. The decorating process takes approximately two months to accomplish.

Going about his tasks, he was thinking of nothing in particular when he heard his name being called from a distance behind him. Turning to answer, he spotted no one. Thinking that he had just imagined it, he went back to work. About five minutes later he heard his name called again, once again turning to reply. As with the first time, there was no one there.

Beginning to think that one of his co-workers was playing a practical joke on him, he went back to his duties and, as if he were an animal waiting for his prey, waited for the next uttering of his name.

Just as he had suspected, his name was once again called out, but this time he was ready—or so he thought. Spinning around with a quickness he had not used since his youth, he thought he had the jokester this time. However, the joke was on him. Well, maybe not a joke exactly; it was more like a jolt. He came face to face with George Vanderbilt. He recognized Vanderbilt instantly from all the portraits he had seen in the house as well as in books about the estate.

Reeling backwards, stumbling and falling over a stool, the stunned and frightened man crawled along the floor on all fours, trying desperately to regain his balance. Realizing it was useless; he lay on the floor, awaiting whatever his fate was intended to be.

He said Vanderbilt slowly approached him with a smile upon his lips, amused by his antics. When he got in front of the man, he stopped and folded his arms across his chest and looked about, as if reviewing the progress the worker had made. Smiling broadly, Vanderbilt then nodded in the man's direction and turned and walked out of the room.

The gentleman told his closest friends about the event and stated that Christmas has had a whole new meaning to him ever since.

A former tour guide at the home relays the story of how she met George Vanderbilt. On her tour one day, she had a rather large group at hand and, being careful that everyone stayed together, would constantly watch the back of the group to ensure they were all there.

Near the end of this particular tour she noticed a gentleman that had lagged behind the rest and was staring at some art on the wall with his back to her. As she finished her presentation at this stop she approached the gentleman, now fifty feet or so from the group, to ask him to return with the rest. When she spoke to the gentleman he did not respond at first. Thinking he may have a hearing problem, she reached out to touch his shoulder. She did not meet the solid feel of a human; her hand actually moved through his body!

Retracting in horror, she tried in vain to scream but could not.

At this point, the gentleman turned to look at her, and much to her surprise it was the exact likeness of George Vanderbilt. All of this only added to her feelings of fear and she bolted for the front door of the mansion, leaving her astonished guests in the lurch.

It is said that she left the property in a flash and has never returned.

The Biltmore Estate is open year-round with holiday tours beginning in November. It is not only spectacular, but if you are really lucky it just might be a breathtaking experience of another kind. If you are on a regular tour and spot a gentleman observing a piece of art all alone, perhaps you will want to think twice about approaching him, although George Vanderbilt has always acted kindly toward all of his guests.

The Resident Spirits of the L.B. Jackson Building

Towering above its neighbors in Pack Square in the heart of downtown Asheville is the L.B. Jackson building, replete with its Gothic adornments. The style of architecture is that of Spanish Renaissance.

There are a number of facts that make not only this building, but also its four neighbors, very unusual.

This block, with the five buildings that literally share walls with each other, is considered the most architecturally unique in the country. All of the buildings were constructed between 1904 and 1925. Each has its own style of architecture, unlike any other block in the country.

Fortunately, these buildings remain to this day due to the fact that Asheville repaid all of its pre-Depression era debt and could not afford to tear them down or replace them with more modern structures.

Mr. L.B. Jackson was a developer of some note during the roaring twenties, and the L.B. Jackson building was the first high-rise in the

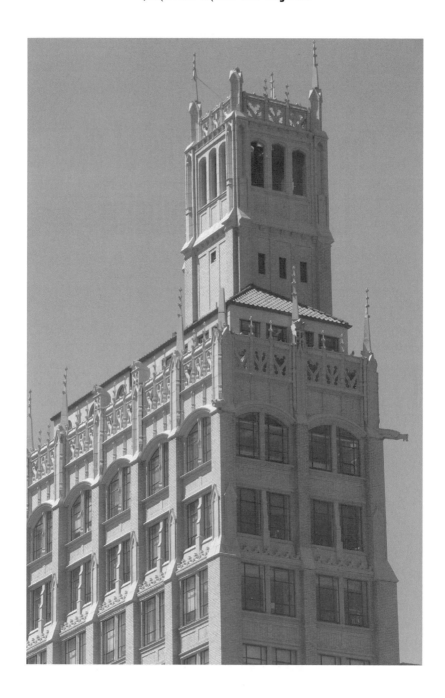

downtown area. Built between 1924 and 1925, Mr. Jackson was just twenty-seven years old when he completed it. The building is unique in that it sits on a very small piece of property just twenty-seven by sixty feet. It rises twelve stories high with a Gothic tower perched atop, which reminds one of the film *The Hunchback of Notre Dame*. The bell tower that was used in the 1939 movie is the tower of the L.B. Jackson building.

When Mr. Jackson purchased the property, he did so from a gentleman named William Oliver Wolfe just prior to his death in 1922. Mr. Wolfe ran his tombstone engraving business from the locale for many years. If the name sounds familiar to you then you have most likely guessed that he was related to the famous author, Thomas Wolfe. William Wolfe was Thomas's father. As a matter of fact, the building next to the L.B. Jackson is the Westall building, built by J. M. Westall, who was the uncle of Thomas Wolfe.

On the Gothic tower there are four gargoyles of leopards, one on each corner of the building, and they lend an eerie presence to the structure, especially on a lightning-filled stormy night.

Once again we have arrived at the inevitable legend.

After completion, the L.B. Jackson building soon filled to capacity with different businesses. Times were good and money was easily made for any enterprising businessman of the era.

On the twelfth floor resided one of the typically successful businessmen of the day. His view was spectacular, overlooking the majestic mountains sprawled out before him that reached, it seemed, to infinity.

One can imagine how satisfying his life was during this period, at least until Black Tuesday, October 29, 1929, the day of the infamous crash of the stock market. His fortunes quickly dissipated, much like the melting snows of winter as spring approaches.

Soon he found himself with no assets or cash. Becoming totally depressed he contemplated his miserable situation and decided,

obviously, that life was no longer worth living. He came to his office one day for the last time. Looking forlornly out of his office window, he gazed across those once beautiful mountains, that once represented all that was right with his life, now seemingly drab and ugly.

Justifying the final action he was about to undertake as being the only resort, he plunged to his instant death twelve stories below. Landing on the sidewalk, he lay there in a devastated manner, blood oozing from his skull and mouth, eyes wide open, staring in horror at the realization of what he had done.

The second spirit that resides in the building is that of a woman in her early thirties. Witnesses to the event recount that on a summer day in 1942 they noticed this woman leaning out of a fifth-floor window. She was leaning from the waist, her torso protruding from the window; she was shouting something that seemed unintelligible. Some on the streets below thought perhaps she was trying to hail a taxicab, while others said there was no taxi in sight.

She continued to yell, all the while leaning farther and farther out the window. Unable to maintain her balance any longer, she tumbled to the sidewalk some fifty feet below. Instantly upon landing she was met by the Grim Reaper, who tried to escort her to the other side. He was faced with resistance when she obviously felt the need to return to the place of her demise to finish some unknown task.

The current tenants frequently report both of these poor lost souls in the building.

One particular tenant who often works late into the night has apparently had many encounters in recent memory. She says she is commonly the only tenant on the twelfth floor late at night, and it is at these times that she not only hears, but also feels the presence of someone or something in the office and

the hallways. By the way, she occupies the same office as the devastated businessman!

One particular event she relayed was that of a long day at work. It was approximately eleven o'clock at night and she was about to wrap up for the evening. As she started to put away a few remaining files, she was suddenly knocked backwards, landing in her office chair. Frightened beyond belief, she twisted and turned violently several times in her chair, desperately attempting to see her attacker. Nothing was there. Nothing at all!

She believed her eyes to be playing some weird trick on her. Staying seated for a few minutes to regain her composure and breath, she finally calmed down and mentally went over and over the event she had just experienced. Not being able to come up with any concrete evidence as to why this had happened, she started to believe that maybe she had simply slipped and fallen back into the chair. But how could that be? She felt someone push her and had felt a presence in the room at that moment… or had she?

Now totally exhausted, she decided to put it out of her mind as best she could and go home. She feared that she could never explain this to anyone.

It was only many years later that she finally became comfortable enough with the occurrence to speak of it. She said that an event like the one she experienced never occurred again. Thinking about all of the strange noises and events, she began to believe that we share this earth with the spirit realm.

Both of the apparitions have been filmed on more than one occasion, staring from the windows late at night, and a good number of spirit orbs appear around the outside the L.B. Jackson building.

Please visit this most interesting of blocks in Pack Square and observe the amazing L.B. Jackson building. There is much more to it than just stone, steel and mortar. Much more!

The Legend of Helen's Bridge

Just a stone's throw away from the L.B. Jackson building is Beaucatcher Mountain. On this mountain sits a stone bridge that replaced the original wooden one. This is the where the legend of Helen continues to this day.

But, alas, I find myself telling of the end instead of the beginning. My apologies, dear reader.

Back in the late 1800s, there was a gentleman by the name of John Brown who built a large stone mansion in the shape of a castle upon Beaucatcher Mountain. Mr. Brown had come to Asheville in the 1840s from Pennsylvania. He left North Carolina to seek his fortune in the California Gold Rush of 1849 but met with minimal success. He ventured on to New Zealand where he made it rich as a sheep rancher.

Returning to Asheville in 1884, he immediately set about the building of his stone castle, which he named Zelandia in honor of his beloved second country of New Zealand.

Sir Phillip Henry purchased the home around 1904. Originally from Australia, Sir Henry was a renowned world traveler, scholar

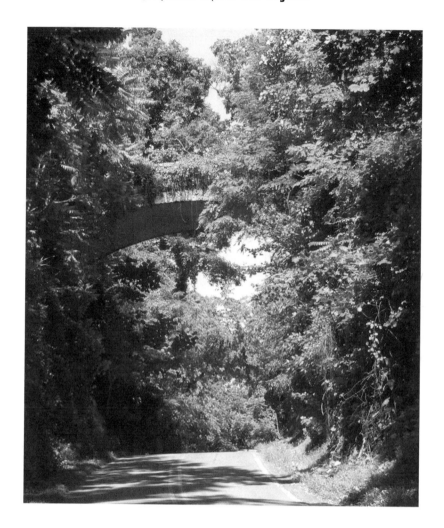

and patron of art. He amassed a huge art collection and opened
Zelandia to the public as an art museum in 1930.

During this era there was a woman named Helen who lived on
Beaucatcher Mountain in a modest home below Zelandia. She
was a God-fearing woman who had only one thing she considered
precious in this world: her only daughter.

One day Helen's daughter had been given permission to play
with one of the children at Zelandia. Unfortunately, they played in

the only room in the house made solely from wood. It caught fire and burned to the ground. Helen's daughter perished in the fire.

One can only imagine the depths of Helen's despair after having lost the only thing in the world that mattered to her. When she was walking home that evening from Zelandia she came to a bridge on the road where she found a length of rope tied to the railing of the bridge. In a final moment of anguish, she tied the loose end around her neck and plunged over the side, hanging herself.

No one found Helen until the next morning when the residents of the mountain set about their daily routines. They discovered her gently swaying back and forth from the bridge. The scene was certainly a grisly one indeed!

From that time to the present, when drivers pass under what is now called Helen's Bridge, they often see a woman dressed in an all white, old-fashioned dress. Helen has been spotted standing alongside the road, as well as under and on top of the bridge.

One gentleman had a typical viewing of Helen one late night. He said that when he had driven under the bridge he noticed a woman in a white dress climbing up the side of the mountain from the bottom of the bridge toward the top.

Thinking that she was in some sort of accident, he stopped the car, rolled down his window and shouted out, asking if she needed any help. The woman turned and started back down the side of the cliff, walking toward him at a very slow pace. She had an extremely pale complexion and a totally blank look upon her face.

As she neared the car, he yelled out once again, asking if she needed any help or wanted him to call an ambulance. He said that she simply stared a hole right through him and with a very eerie voice asked, "Have you seen my daughter?" He said that he finally was able to compose himself to the point to answer, "No, I have not." At this juncture she turned with a flurry, quickly glided up the side of the mountain and disappeared.

He started to remember the long-told story of Helen and the bridge and a cold shudder came over him. Racing down the remainder of the mountain, he headed straight for the police headquarters in downtown Asheville to file a report.

To say the least, the man has never driven that road again.

One of the owners of the mansion was a company by the name of Peppertree Resorts. They used the facilities as their headquarters for many years.

It was a common occurrence for the employees to report strange events going on within the house. When arriving at work, the employees would open the front door of the office and the photocopy machine would be running, spewing out blank paper all over the floor. When this occurred there was never anyone else in the office. Also, windows would be opened on the unused second floor; these windows had previously been nailed shut.

Reported often were lights turning on and off, toilets being flushed and items falling from shelves.

About ten years ago, the home was sold to a married couple that has since renovated the home. It now looks nothing like the original castle structure.

The couple has reported that they too experience the same types of strange phenomena as reported by the prior tenants. Since they live in the house twenty-four hours a day, they report one additional strange event: from time to time they see a woman, dressed in what appears to be a formal black dress, much like one worn many years ago by someone attending a funeral. The woman literally glides through the mansion, as if she were floating on a cloud.

One can only imagine that it is the spirit of Helen who returns to seek out the spirit of her only daughter.

A friend of mine relayed a unique story from some years ago concerning the legend of Helen's Bridge. Her name is Nancy, and

she is a native of Asheville. During her time at the University of North Carolina at Asheville, she decided one semester that she would do her term paper on the legend of Helen.

On an impulse she decided to drive up to Helen's Bridge very late one night, and she parked directly under the bridge. She waited for hours to no avail. Nothing appeared. Discouraged, she left.

The next day she was talking to a classmate, telling her about the term paper and what she had done at the bridge the night before. Her friend said that she definitely needed to meet an elderly couple that she knew here in Asheville, and the next day arranged for them to meet. Upon arriving, Nancy was introduced to the husband. Then, from behind a screen door, emerged the wife. At first she appeared to be very skeptical of the newcomer but warmed up quickly when Nancy's friend told her why they were there.

She started by telling them about how her son had done the same thing as Nancy, but he was told that if you beckoned to Helen, saying three times "Helen, come forth!" that she just might appear. She said that Helen had appeared to her son. She came up to the back of the car, and he spotted her in his rearview mirror. She placed her hands on the trunk, and then shortly afterwards disappeared.

The mother took Nancy to her son's bedroom to introduce her. Nancy stated that he was heavily sedated and not normal. Nancy inquired as to what was wrong with the son, and his mother replied that Helen had driven her son insane under the bridge that evening long ago.

Dismayed and saddened by what she had seen and heard, Nancy headed out of the house expecting to drive off with her friend, only to be left with her thoughts and contemplations of what she had learned from the old woman.

Before they could bid their farewells, the wife said she had one additional thing she wanted to show Nancy and her friend. She escorted them to the garage and she slowly, with some effort,

raised the door. Sure enough, there was what was obviously a car underneath a tarp. Silently the old lady advanced toward the car and pulled the tarp from it, unveiling what she stated was the car her son had driven that night to Helen's Bridge.

Without saying another word, she pointed to the trunk area of the car, and sure enough there were two plainly visible handprints.

She then walked over to the passenger side door, opened it, and withdrew two pieces of paper. Turning, she handed them to Nancy and explained that they were receipts from two separate body and paint shops in the Asheville area.

After examining the papers, Nancy said they were both expensive paint jobs. The old woman explained how on both occasions, after the return of the car from the shops, the handprints had floated back to the top of the paint surface. She then proceeded to buy every cleaning product she could to try and erase those prints, but to no avail, they always returned.

She told Nancy that she no longer tries to get rid of the handprints and now maintains the car in its current condition, as proof that Helen had driven her son insane that night under the bridge.

There are tourist maps available at no charge in the downtown Asheville area that will easily direct you up to Helen's Bridge on Beaucatcher Mountain. It is only most interesting if visited late at night and only truly intriguing if you call out for Helen to come forth three times. You must sit in total silence, for she will only come if there is no other noise present.

May you have a most pleasant and memorable visit.

The Legend of Count von Cosel

There is a legend that has part of its roots here in Asheville but concludes in Florida. It is a tale of the weird and the bizarre as well as the paranormal.

Let's begin the journey by introducing you to the lead player, Karl von Cosel Tanzler. Karl had grown up in Dresden, Germany, and was raised by his grandmother.

He was an odd child who never quite fit in with his peers at school. Growing up, Karl declared many times to his grandmother that he had visions of his soul mate and he would meet and marry her one day.

An intelligent and studious young man, he eventually received nine university degrees in engineering, science, the medical field and quite a few others.

Around 1920, Karl moved to the United States, traveling about and doing odd jobs to survive. At some point he traveled to Asheville, where he met the woman who was to become his wife. Together they had two daughters, and all seemed well for a while.

Around 1927, the Tanzlers left the area and headed down to Florida. Their history is rather sketchy, but after arriving in

Zephyrhills, Florida, Karl left his wife and daughters.

He next turned up in Key West, Florida, in the year 1927. He now proclaimed himself to be Count von Cosel, and let everyone who would listen know that he had obtained nine different university degrees in Germany.

Key West was a poor city during this period. By the beginning of the Depression in 1930, Key West was five million dollars in debt and had no police department, fire department or civil servants whatsoever. Having 80 percent unemployment, it was very difficult to find any job, but the Count was able to obtain a position as an X-ray technician at the marine hospital on the island.

One day a beautiful young Cuban woman by the name of Elena Hoyas was admitted to the hospital, dying of tuberculosis. Count von Cosel immediately became obsessed with Elena, for he felt he had finally met his soul mate.

The Count was a man most guessed to be in his late fifties or early sixties, and Elena was just twenty-two years old.

The Count would spend all of his spare time working to find a cure for Elena. When he was off duty he would sit with her for many hours on end, reading and talking to her. He lavished many gifts upon her, which she accepted, and asked many times for her hand in marriage, which she rejected.

Despite the Count's very best efforts, Elena died in October 1931.

Her family was as poor as everyone else on the island and could not afford an elaborate funeral for Elena, let alone a headstone for her. She was interred in the Cuban section of the Key West cemetery.

About two months after the funeral, the Count was unable to stand the fact that his soul mate had not received an appropriate burial. He went to Elena's family and made a request. He asked permission to rebury her in an elaborate marble mausoleum. They

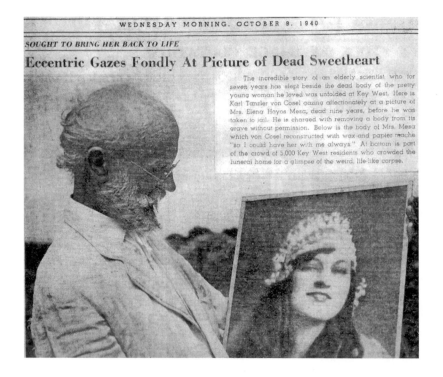

WEDNESDAY MORNING, OCTOBER 9, 1940

SOUGHT TO BRING HER BACK TO LIFE

Eccentric Gazes Fondly At Picture of Dead Sweetheart

The incredible story of an elderly scientist who for seven years has slept beside the dead body of the pretty young woman he loved was unfolded at Key West. Here is Karl Tanzler von Cosel gazing affectionately at a picture of Mrs. Elena Hoyos Mesa, dead nine years, before he was taken to jail. He is charged with removing a body from its grave without permission. Below is the body of Mrs. Mesa which von Cosel reconstructed with wax and papier mache "so I could have her with me always." At bottom is part of the crowd of 5,000 Key West residents who crowded the funeral home for a glimpse of the weird, life-like corpse.

didn't see any problem with his request and granted him his wish.

The Count did as he had promised: he built a beautiful mausoleum and had her remains moved into it. He placed a marble bench beside the mausoleum so that he could visit her daily.

He would sit every day, talking and reading to her, much as he had done in the hospital. He wrote in his journal that Elena would speak back to him, asking when he was going to remove her and take her with him so they could be together forever.

On the days that the Count could not go to the cemetery, due to his schedule or bad weather, he simply had a telephone installed at the mausoleum, so that he could still talk with Elena.

This went on for almost two years, and finally he succumbed to her wish of being together. He snuck into the cemetery late one night and exhumed her body.

As you can well imagine, after being in the heat of Key West for almost two years, there was not much left of poor Elena. Her body weight was only about forty pounds as most of her skin and flesh were rotted away.

He did, however, return what remained of Elena back to his home, where he placed her in an airship that he had constructed on one side of his house. He christened the airship "Countess Elaine," and one day he planned to fly with Elena to the stars.

The Count attempted to resurrect Elena with a variety of materials. He used plaster of Paris to form most of her torso, glass eyes where her real ones use to be, silk and mortuary wax to form out her vital parts, such as her face. He took her own hair and made a new and fashionable wig for his Elena.

Then he dressed her in a beautiful silk wedding dress, propped Elena up in a makeshift bed in the airship and piled mounds of silk all around her. He placed a blue light above the bed—according to him it gave her a heavenly glow—and a sign above the bed that said "Laboratory." Count von Cosel was assured that he would one day find a way to bring Elena back to life.

I promised you a strange and bizarre story, didn't I? Well, we have only just begun.

The Count kept Elena in the airship for seven years, attending to her daily with ointments, salves and lotions to help preserve and make her all the more beautiful.

Rumors were widespread on the island as to the Count's activities during this period. One day, Elena's sister decided to investigate the truth for herself. To her horror she discovered that truth by sneaking onto the Count's property and looking inside the airship. What see saw was a likeness of her sister Elena. Terrified, she ran to the Key West police, and they returned to investigate the scene. They arrested the Count on charges of grave robbing and returned Elena's body to the Dean Lopez funeral home.

Folks, I am not even finished with the normal part of this tale yet.

The morticians at the funeral home reported back to the police that Elena's body had been made anatomically correct in almost every detail. They said that her breasts had been made of some type of rubberized material, and they felt almost human-like. They also discovered a piece of tubing inserted at the "Y" of her legs.

There was so much interest in this story, not only locally but also nationally, that Elena's family granted a public viewing of their daughter's body. The funeral home took her casket and removed the lid. They propped it up on a steep angle in the front door of the funeral home, so that anyone interested in viewing the remains could pass by on the sidewalk below and see Elena, or what she had become. Over a three-day period, 6,853 people registered to view her body. To this day it remains the largest public viewing of a corpse in Key West history.

There was much furor about the upcoming trial of the Count, and the press from all over the country was in attendance. Actually, there was much sympathy for the Count, as many felt that it was a very romantic thing he had done to be with the one he loved so much.

The Count had admitted that he had treated Elena as his wife for the entire seven years she was there.

When the case came before the local judge, he simply dismissed the charges, stating that the statue of limitations had expired on grave robbing.

The court highly encouraged the Count to leave the island, knowing, but not expressing, that he was insane.

The Count returned to Zephyrhills, Florida, and lived with his former wife, the lady from Asheville, until he died in 1952, well into his eighties by then. Many in the community believed that it was actually his sister with whom he stayed, and most likely the couple allowed that perception.

Well, that ends that story, correct? Not quite yet.

When the police arrived at the house that day the Count died, they found his body slumped in the hallway in front of his bedroom door.

Low and behold, when they opened the door, to their shock and amazement, they found another body that looked just like Elena in his bed.

After examining the body, the conclusion was that this was the same "body" that he had created in Key West. It is believed that someone who had buried Elena the second time in Key West made a switch, loading the coffin with bricks to imitate her weight, and returning the body to the Count.

His ex-wife also made a confession to the police that she had been terrified to make while the Count was alive: he had continued to treat Elena as his wife in *every* respect of the word for the entire twelve years he lived in her home.

Now, folks, *that* is strange!

Conclusion

Hopefully, you have been enlightened to the darker, the weird and the bizarre, but certainly an entertaining and interesting side of Asheville, North Carolina.

Most people believe that you have to visit certain places in the world to be able to find a lot of paranormal activity but nothing could be further from the truth. The entire world is haunted, and one only has to venture a short distance in most cases to find evidence of that fact.

Some areas are more active than others when it comes to paranormal activity, due to many factors. Areas with a large amount of deaths, such as sites of former battles or catastrophic disasters, tend to have more activity.

Asheville is located along the longitude at the top of the infamous Bermuda Triangle, where a high volume of paranormal activity exists. This energy is transferred around the globe between those longitudinal lines, affecting the activity within its boundaries.

The stories you have just read are but a few that exist in the Asheville area. You can find many legends in your own area simply by talking to friends and family, doing research at your local library,

searching old newspaper archives and talking to longtime local residents. What you will discover is a whole new world previously unknown to you.

At this juncture, I feel that I should explain exactly what spirit orbs and apparitions are.

First I should state that my definitions of the aforementioned subjects are very specific and are based solely upon my own experiences and beliefs. There are other varying opinions that may have merit, but over the years I have grown comfortable with my views, as I have found they are consistent.

A spirit orb is the energy field emitted by a ghost, spirit, poltergeist or any other terms used for those who remain in the spirit realm. Orbs are round by definition and vary greatly in size, brightness and patterns. When observing the image of an orb captured by a digital camera and magnified on a computer, one can see some very interesting details. What I find consistent with orbs is that the vast majority of them have a similar pattern. The pattern appears much like that of an English garden maze. Also, the colors are often detectable and can be green, red, blue, yellow, gold, black or a number of other colors. Why the colors? My belief is it closely matches that of the human aura.

Again, one question leads to another: what is an aura? We all emit from our bodies a light field, called an aura. This aura is the result of the electrical currents that are produced in each of us, and is necessary to sustain life.

There is a fairly easy method to view one's own aura. It requires two people. At night, have one person stand in a doorway opening in your home. Make sure there are no reflective surfaces behind you in the hallway, such as mirrors or pictures with glass covering them. The other person should stand about ten feet away with a camera, preferably a digital one. Now, turn out the lights so it is pitch black.

Conclusion

Stand in the doorway for about thirty seconds; then step off to the side so you cannot be filmed. Tell the cameraperson to snap a picture of the doorway. What will appear on the picture should be the imprint of your aura that was left from your presence there.

Download the picture into your computer and examine it. You will see multiple colors. These colors, it is believed, denote your personality type. There are charts available that describe the personality traits of each of the colors.

When a person remains in the spirit realm their aura is transformed from our physical body shape to an orb, but the colors still remain, as spirits do not change their personalities.

With pictures of apparitions or ghosts, these auras will appear in a wide range of forms. I believe that the longer a spirit remains in the spirit realm, the more they lose their human shape, as it is no longer of any use or value there. With this in mind, you will capture apparitions from a simple wisp of smoke to a completely formed silhouette of a person.

Why can't most people see this phenomenon? Very few people have eyes sensitive enough to see into the spirit realm. On occasion, paranormal activity will be strong enough for anyone to be able to see, but the vast majority of the time it is not. That is why cameras are such a wonderful aid in discovering the spirit realm. Digital cameras are even more sensitive than conventional film cameras.

Another phenomenon that I particularly like to capture on pictures is the streaking orb. A streaking orb is one that is moving at the time you snap the picture. It can cause long streaks of light to appear on the picture and will form some extremely interesting patterns.

Here is another fun experiment that is very easy to do. Go to a quiet cemetery in your area, preferably in the country with no traffic noise. Take a tape recorder—an inexpensive one will work.

Walk to the edge of the graveyard and turn on the recorder as quietly as possible. Let it record for a minute or two. Now, stop the recorder. At this point, I am going to ask you to do something that may sound weird: I need you to talk to the remaining souls that reside at the cemetery. Yes, talk to the spirits. They hear us as we hear each other in this realm. They are curious to hear what you are saying and anxious to tell you their story. Don't believe me, huh? I know it sounds strange and feels awkward to talk to nothing but air, but the results of your efforts will astound you. After talking in a normal tone of voice for a couple of minutes, turn on the recorder again and record for several minutes.

Rewind the tape to the beginning and simply listen. The first part should be clear with no sounds, but the next section should be filled with static, better known as white noise. If you had some very sophisticated equipment you could decipher the white noise and actually hear the spirits talking to you.

As with all cemeteries, many of the interred have not been able to move to the other side for a variety of reasons, and they become very active, especially at night. When you take your camera and recorder with you to any cemetery and see all that you can pick up, you will be amazed!

My hope is that you now have a new understanding of the forces around us constantly. They are just out of sight, but nonetheless there. Know that you are being looked after by friends and loved ones who have passed before you.

If you have ever heard the little voice inside your head telling you to take a certain direction, make a certain choice or simply whether to believe something or not, then you have experienced those loved ones trying to help you.

If you learn to truly listen to those voices, then life will be less complex and more enjoyable.

There is nothing to fear from the paranormal. When people pass

into the spirit realm or the other side, their personalities do not change from what they were in this dimension.

Hollywood has created the myths about evil ghosts that wanting to inflict harm to the general populace. Have you ever personally met someone who was truly evil in this realm? Chances are that you have not and will not from the spirit world.

Now grab your cameras and tape recorders, and gather up your friends and family. Head out to the nearest cemetery, old church, hospital or haunted house and follow the directions you were given earlier, so you too can begin to get a better understanding of the spirit realm.

Happy hunting!

Visit us at
www.historypress.net